2/03

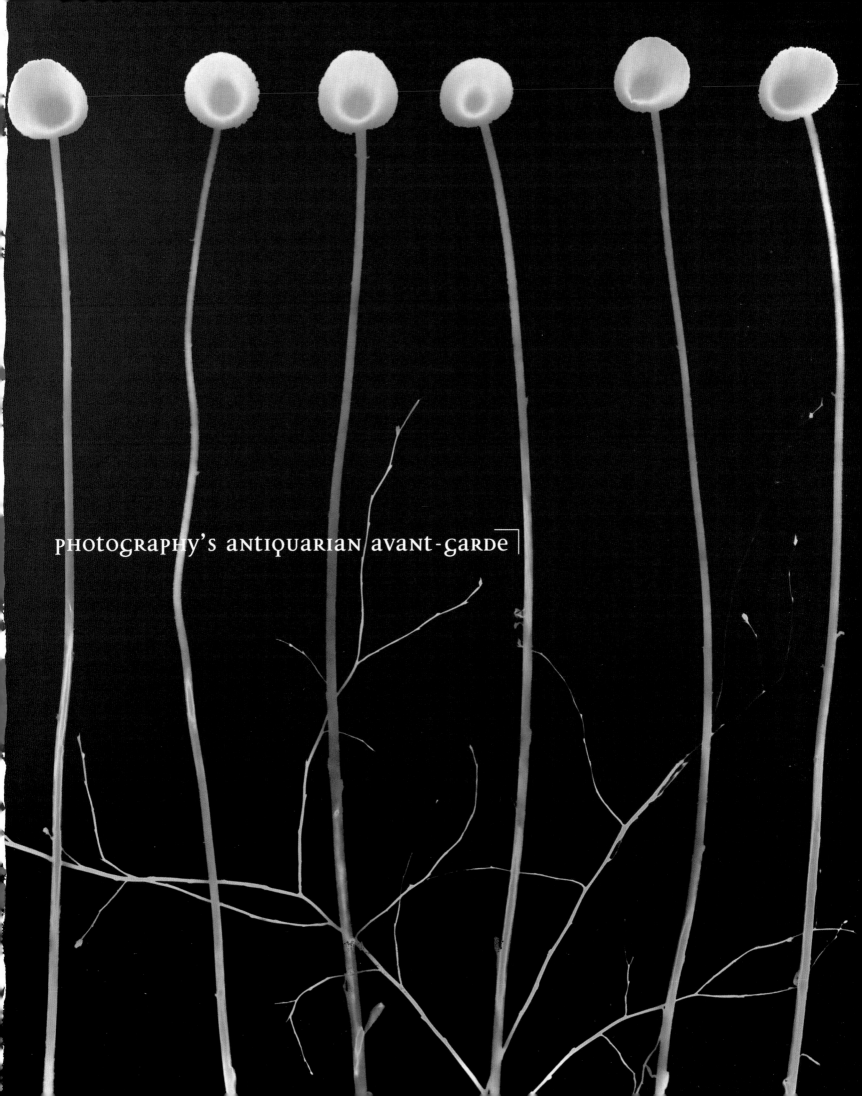

PHOTOGRAPHY'S ANTIQUARIAN AVANT-GARDE

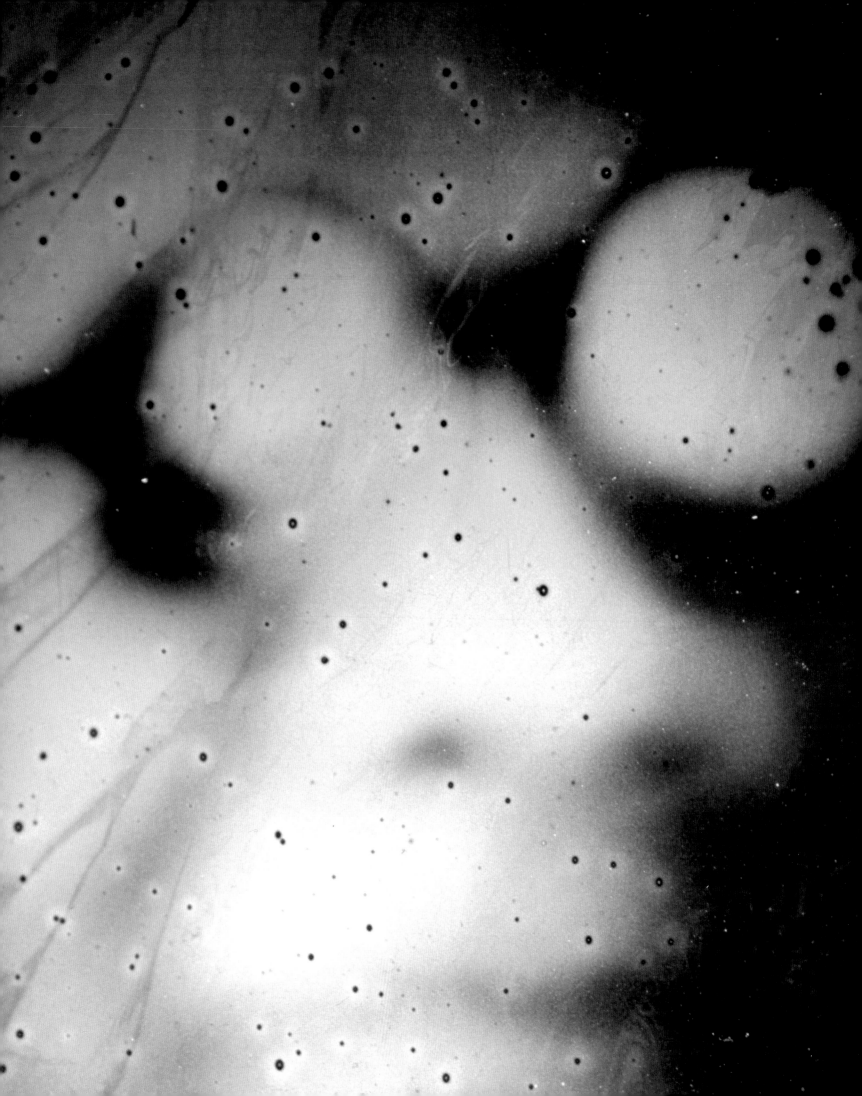

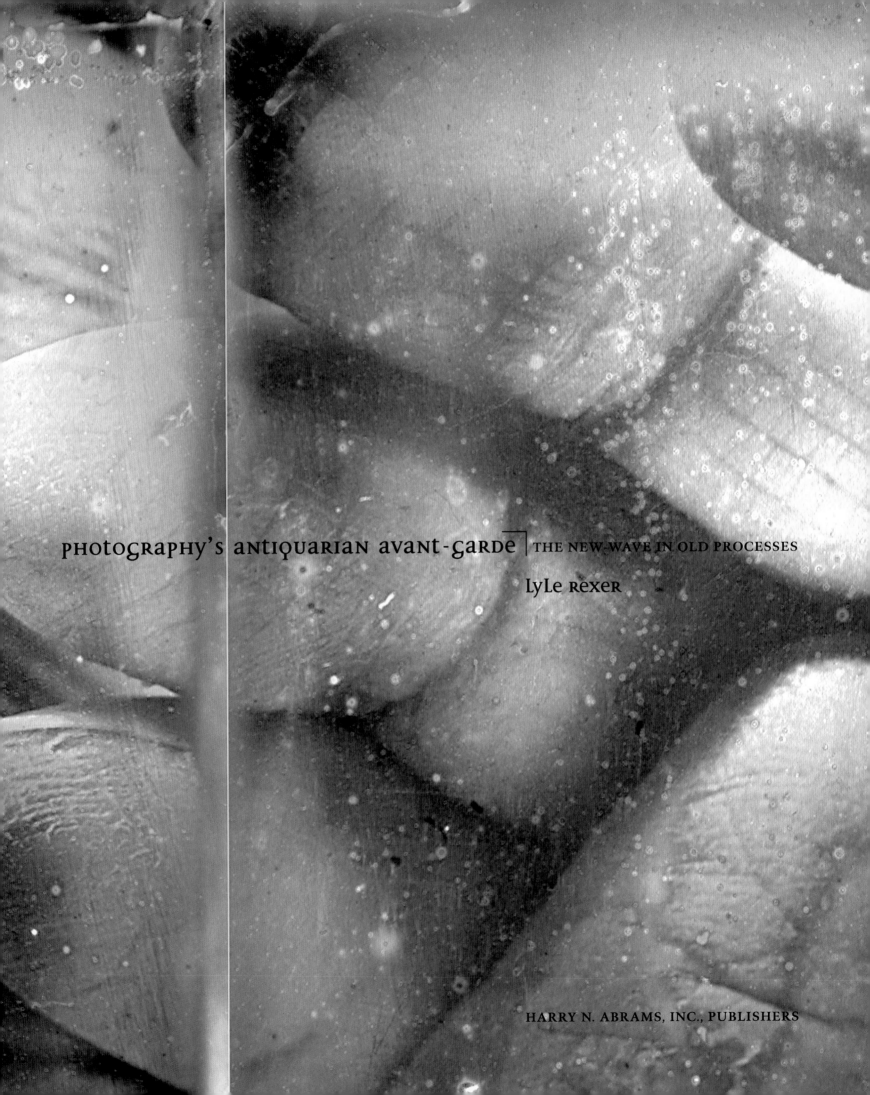

# photography's antiquarian avant-garde | THE NEW-WAVE IN OLD PROCESSES

## Lyle Rexer

HARRY N. ABRAMS, INC., PUBLISHERS

THIS BOOK IS DEDICATED TO MY PARENTS, HENRY AND CAROLYN REXER

This book began at the suggestion of my wife, Rachel Klein, who, after a visit to the exhibition *Inventors + Alchemists* at Sarah Morthland Gallery in 1998 said, "Hey, why don't you write about this?" Since then, I have presented some of my initial ideas in articles in *The New York Times,* and I want to thank my editor there, Annette Grant, for furthering this "crooked work." Portions of my introductory essay appeared in slightly different form in the volume *In Human Touch,* published by Nazraeli Press. I would like to thank the University of Michigan Museum of Art for permission to reproduce it here. All the artists and galleries mentioned in this book have contributed to it; there isn't room to list them all. A core group of people has encouraged this project from the out-set: Sarah Morthland, who first championed this work and put it on the wall, Jonathan Bailey, Dan Estabrook, Mark and France Scully Osterman, Jerry Spagnoli, and Sarah Hasted and Bill Hunt at the Ricco-Maresca Gallery. Sally Mann and Chuck Close put up with my extensive inquiries, and Christopher James shared sections of his book with me. Graciela Sacco opened the door to Argentina, Sándor Szilágyi to Hungary, and Martin Becka to France. Charles Wehrenberg, Jenni Holder of the Edwynn Houk Gallery, Jossi Milo of Jossi Milo Gallery, Karen Haas of the Boston University Art Gallery, and Judy Seigel of the *World Journal of Post-Factory Photography,* opened other doors. Irving Pobboravsky, Ken Nelson, and Chris Mahoney supplied valuable historical information, and Hans Kraus and William Schaeffer generously provided beautiful nineteenth-century images. The Ostermans allowed me to steal the title of their exhibition for Chapter 4, and Ellen Carey lent her coinage of "photography degree zero" to Chapter 7. Several people consented to read the manuscript, and their comments have been invaluable: Mark and France Scully Osterman, Larry Schaaf, Jerry Spagnoli, and Jayne Hinds Bidaut. Finally, I want to thank my collaborators at Abrams. This book owes its order to Deborah Aaronson, my editor, and its beauty to designer Brankica Kovrlija. It owes its existence, however, to senior editor Harriet Whelchel. Many people thought the book was a good idea. She made it happen.  L.R.

# contents

An invention starts as a curiosity, extra to what seems necessary. We may regard it at first from a mental distance of amusement or amazement, as something bizarre or exotic. Then, if successful, the invention moves in, bringing pandemonium. Like the rearrangement of our furniture, it alters familiar terrain. It disrupts habits, roughs up values, and generally remolds us—dramatically, like the automobile; subtly, like the microchip—into different people in a different kind of world.[1]

PETER SCHJELDAHL

In 1995, the Museum of Modern Art announced that it had purchased directly from the artist Cindy Sherman the original prints of the series *Untitled Film Stills* at a price of more than a million dollars. These fictitious images of stereotypical Hollywood and tabloid snapshot views, with Sherman as the main character, signaled a turnabout for a museum that had championed the idea of photography as a distinctive art, with unique formal and aesthetic properties and a history all its own. Suddenly enshrined with the Sherman acquisition was a species of antiphotography, an art of cultural documentation in which the fact of picture taking, its accumulated social meanings ("film stills"), and the position of the observer (photographer and viewer) were far more important than the composition of the images or the material matrix of their presentation. The medium that had from its inception played upon the ineffable effects of light was now bathed in a lurid glow. For although this antiphotography was corrosively self-aware and politically astute, it paid no attention to itself, that is, to the mediating circumstances of paper, printing process, composition, texture, tone, and moment that had for almost a century signified a work of photographic art. At the apex of photography's artistic ascent, the moment of its cultural and economic ratification as art, photography as such had become as invisible as light itself.

In the 1990s, other avatars of what is called postmodernism showed how little traditional aesthetic values had come to mean for camera art. Thomas Ruff, for example, was doing for the human face and form what his teachers Bernd and Hilla Becher had been doing over decades for the industrial landscape—rendering it existentially naked, stripping it of associations and projections, and using the camera precisely to deny the claims of personal expression and authorial intervention that earlier photographers had fought so hard to establish. Other provocateurs took aim squarely at the photograph's documentary status and with it the artistic nexus of world, camera, and photographer. Jeff Wall's invented sociopolitical tableaux and Mariko Mori's New Age sci-fi setups, to take just two examples, undermined photography's putative relation to things seen, with fabricated correlatives of their sexual and political intuitions. "Photography," having acquired a permanent set of self-conscious quotation marks, provided a view of "reality," also in permanent quotation marks. As in its most mundane mimetic applications, photography in postmodern hands became merely a window, albeit on a dubious world.

And if traditional photographic practice, with its darkroom alchemy, coterie secrets, and tactile fascinations, needed another blow, it suffered the worst from within its own milieu, from the camera itself. In 1982, Sony demonstrated the first electronic digital camera, a leveling event that suddenly moved the entire complex of image-making activities into a new flatland of digital data. Perhaps the aesthetic impact of the photograph is, in the end, only a matter of output, but digital technology not only threatened to rob photography of its "rhetoric of truth,"[2] it also privileged certain image qualities unrelated to the physical print, including graphic arrangement, ideational content, and cultural encoding. These qualities translate across media and do not depend on the texture of any one of them. This virtual interchangeability, existing in a nowhereland free from the action of light and time, represents the polar opposite of the Modernist camera aesthetic of Alfred Stieglitz, Ansel Adams, Edward Weston, and so many others.

To a growing number of artists, however, photography's 1995 funeral was premature. At about the time MoMA announced the

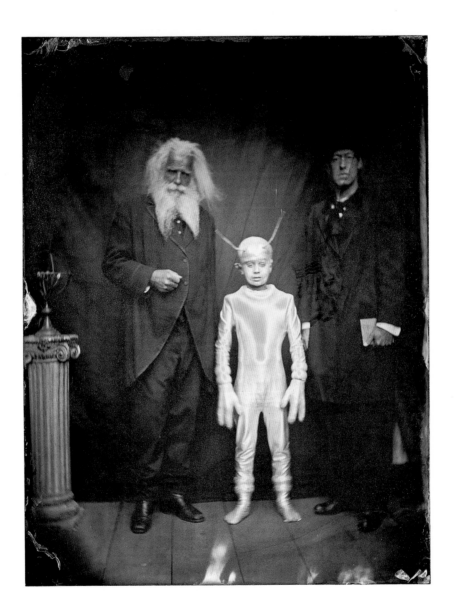

stephen berkman

the exhibit (from the archives of the academie des sciences). 2000. ambrotype, 10 x 8 inches

*Untitled Film Stills* purchase, Jayne Hinds Bidaut, a photographer in New York, had an epiphany of sorts. She had been searching for a way to photograph her collections of beetle, moth, and butterfly specimens when she discovered she could no longer obtain many of the darkroom supplies she needed. She was advised to "go digital." The prospect of photography going the way of the natural environment pushed her toward an act of symbolic resurrection. She began to make *tintypes* of her specimens, positive images on iron or aluminum. The process, invented in 1853, had been defunct in the United States for decades.

Another New York photographer, Jerry Spagnoli, having overcome his initial hesitations about the safety of the process, was creating photographs in *daguerreotype,* the method of recording images on copper plated with silver. Obsolete since the 1860s, the daguerreotype transformed Spagnoli's approach to documentary photography, giving him a means to explore in a single image the collision of lived time and historical time. His series, *The Last Great Daguerrean Survey of the Twentieth Century,* is an archive of contemporary events and places (a New York Yankees victory parade, the press vigil for John F. Kennedy, Jr.) that deliberately plays on expectations of the antique format, transforming familiar places and events into islands of lost time.

In France, a small group of artists was working in a visual tradition closer to printmaking and painting than photography. Exhibiting for a time under the rubric of the Helios Society, artists such as Martin Becka and Martial Verdier developed modern variants of old negative techniques such as calotype, and created hybrid productions that recall the complicated techniques of the early Photo-Secession.

Commissioned by the High Museum in Atlanta, Georgia, to make a series of landscapes for the Summer Olympic year, photographer Sally Mann worked with a large-format view camera and Ortho film at long exposure. The images appeared to be bleached, peeling, even decayed, and created an effect resembling prints made from hand-coated glass-plate negatives, the tools of nineteenth-century photographers such as Mathew Brady. Mann soon began to coat her own glass plates with *collodion,* an antique film emulsion. She was inspired by a cache of nineteenth-century glass-plate negatives she had discovered decades before, and by the landscapes of Mark and France Scully Osterman, who were resurrecting collodion techniques at their studio in Pennsylvania.

In Paris, Israeli photographer Ilan Wolff had turned his van into a *camera obscura*—a chamber with a pinhole to admit light— creating in effect a gigantic mobile version of the most primitive camera. He loaded this dark chamber with large sheets of film and used it to capture familiar views of Paris. Because the camera was room-sized, he could insert himself into the image as a silhouette by standing in front of the film. The result was an updated version of the *photogram,* the first product of cameraless image-making, harking back to William Henry Fox Talbot's discoveries of the 1830s.

Preoccupation with nineteenth-century photographic practices was by no means limited to those adopting them. Joel Peter Witkin made direct reference to the photographic and art-historical past through the staging and photographing of horrific antiquarian tableaux, including severed human heads. He often compounded his references to the past by scratching and otherwise distressing his negatives. Working in Belgium, American-born Stephen Sack created a series of haunting images by rephotographing paired antique *stereograph* images selected from the

Bibliothèque Nationale in Paris. Australian Tracy Moffat, known for her staged and exaggerated color photographs, began to compose costume domestic narratives with a nineteenth-century gothic undertone and print them in the muted brown tones of *photogravure,* a turn-of-the-last-century printing technique.

By 1995 and the apparent triumph of antiphotographic (or photocritical) art, camera artists with a wide variety of attitudes and motives were deliberately re-engaging the physical facts of photography, that is, its materials and processes, and turning to the history of photography for metaphors, technical insight, and visual inspiration. We call the movement to return to old photographic processes the *antiquarian avant-garde.* So mixed are its motives that it might not be credited as a movement at all. Almost every photographer who still enters a darkroom inevitably strays into alternative processes, even if only briefly. Yet conversations with the artists and familiarity with their work—much of it still unexhibited and unpublished—reveal shared intentions, inspirations, and imagery. Although the past informs this work, it is the present that incites it. Old-process photography embodies approaches very different from those of postmodern artists such as Sherman and Wall, but it arises from the same cultural circumstances and the same world, generating similar anxieties and intuitions. The antiquarian avant-garde is anything but antique. It represents a varied response to conditions undermining the traditional practice of art photography—and the very idea of the photographic object itself, not to mention the photographic art object. It is a way for a diverse group of artists, aware of the issues clustering around photography in the twenty-first century, to reimagine and redirect the one truly modern medium of image-making.

JOHN WOOD

Nineteenth-century science allowed this new art to spring, like Athena, full-blown into life—as wise and mature at birth as it would ever be. There was no primitive stage of photography, nothing that resembled cave drawings or aboriginal glyphs.[3]

ROBERT HARBISON

A correspondent wrote to [William Henry Fox] Talbot in 1855 saying that photography was one of the great "poet ideas" of the century, and it is fair to say that this is how he saw it. This medium made a kind of union between man and visible reality, allowing us to look more deeply into all that surrounds us. He delighted to pore over his lilliputian images long after taking them, uncovering with a lens fresh details never seen before. The photographic image was more intricately coded than natural vision, because it held the data in suspension until you were ready to absorb it. We have grown used to the process, but for Talbot it retained its halo of the miraculous.[4]

## THE HALO OF THE MIRACULOUS

The common term applied to the approaches adopted by the antiquarian avant-garde is *alternative process.* There are websites and chat rooms and at least one publication, *The World Journal of Post-Factory Photography,* devoted to so-called alt. process arcana, alchemy, and controversies. The term *alternative* is itself an artifact, left over from the 1960s, when it was coined primarily as a slogan of opposition to Kodak, which threatened to dominate all of photographic processing and materials. The artists featured in this book, however, form an important although not-neat subset. They create images primarily with pre-twentieth-century methods of photography. As of this writing, digital imaging is referred to in the photographic world as an alt. process. Soon, the reverse will be true. Digital will be the standard process of initial photographic capture, and all of darkroom photography, certainly at the negative stage, will likely be considered "antiquarian."

The sources of the antiquarian avant-garde lie in the evolution of photography itself, in the ambiguous attributes of this half-art, half-science that continue to spur its restless innovations. "Evolution," rather than "history" is the right word, for photography has no history as such, as John Wood implies, certainly not one that follows the pattern of painting and sculpture since the Renaissance, with the rebirth of pictorial space, the secularization of the image, and the continual revision of expressive conventions. Nor does photography's evolution as an art follow a narrow technological trajectory. Although photography was never one technology, its full formal potential was given even at the instant of its inception, from the first paper negatives made by Talbot and his tiny "mousetrap" cameras. Just as the Modernism of Edward Weston and Paul Strand was present embryonically in the nature of photography, so too was the contemporary return to a pre-Modernism, whose techniques have simply lain in suspended animation.

Unlike the airplane, steam engine, automobile, and for that matter, almost any other modern technology, photography has no clear genealogy. Although its roots have been traced back to the birth of Renaissance perspective, the desire for accurate, unmediated representation—the primary source of photography's power—is as old as antiquity.[5] The historian Pliny recites a myth about a maiden making a shadow drawing of a lover soon to depart in order to recall his presence and perhaps magically reproduce him. Even the first "keepers of light," those talismanic names of Joseph Nicéphore Niépce, Hippolyte Bayard, Louis Jacques Mandé Daguerre, and William Henry Fox Talbot, represent neither the earliest nor the only imaginers of something like photography. At least two dozen names, including Thomas Wedgwood, son of the famous porcelain maker, and Samuel Morse, inventor of the telegraph, have been listed as "first" photographers.[6] This is not to rehash arguments about who should get credit. Photography is implicit in the desire to fix images constituted by light. The desire was realized only with the advent of the modern industrialized world, the world we still inhabit, a world driven by technological change and a hunger, a need, for the "accurate," reproducible image. At its root, photography has always been merely a technology and at the same time a form of cultural desire so compelling that Talbot could refer to it as "a little bit of magic realized."[7]

Even more telling, the originators themselves could not articulate a single "true" character for the new phenomenon. Talbot called it "photogenic drawing"; Niépce, who pioneered the daguerreotype process, called it "heliography." Both are oxy-

wɪʟʟɪᴀᴍ ʜᴇɴʀʏ fox taʟʙot
**roofline and dormer window.** c. 1842.
salt print from a calotype negative, 4 ⅗ x 3 ⅘ inches

morons combining nature and culture, intention and process. What was photography? An impersonal inscription of nature? A manipulable medium of individual expression? A product of science and handmaiden of objective observation? Perhaps a wholly new form of art? Did photography interrupt the flux of time or eternalize the present? Did it look backward to things disappearing or forward to a new world? The relationship between human subject and photographic object, machine and nature, could not be unequivocally specified. It shifted like the contours of a "waking dream," as the poet John Keats described his vision of a nightingale. This play of ambiguities defines photography's identity and stamps it as quintessentially modern. Its mixed nature accounts for its peculiar evolution, its habit of continually calling itself into question. The questions never seem to be settled, only reinterpreted with each shift of society's angle of vision.

Is photography anything at all? A minimum answer might be, it is the activity of light rendered on or in various media. A camera and lens are not required; nor are silver salts or developing chemicals or even a photographer. Photography has no specific content, province, or use, and so it has no meaning, as such. Its meaning is whatever the maker, user, or consumer, all operating within the culture, ascribes to it. Persistently, however, and because it was born into an artistically secular, self-conscious world, photography's status has revolved around the question of whether or not it is an independent art and in what that art might consist.

Within a few years of photography's "official" introduction in 1839 in London and Paris by Talbot and Daguerre, respectively, photographers were already at work in Singapore, Bombay, and Teheran. Within a few years of Commodore Perry's incursion

into Japan, streets in Tokyo were crowded with ambrotypists, making likenesses on glass plates. Photography was everywhere. By the 1880s, it was estimated that there were ten thousand working photographers in America alone, and this was even a few years before the advent of the Kodak camera, which democratized picture making like nothing before or since. By the turn of the century, photographers had experimented with almost every art genre, including still life, portraiture, landscape, narrative tableau, collage, and even pure abstraction. Painters had used photography from the first as an adjunct to their work. Delacroix advocated the use of the daguerreotype in figure study. Edgar Degas made evocative, if desultory, investigations of photography for its own expressive sake.

Just as the fossil record only hints at the diversity of extinct species, so this thumbnail summary barely suggests the incredible profusion of techniques and materials that early photographers invented, used, and sought to patent. Peter Galassi, curator of photography at the Museum of Modern Art, has called the early decades of photography a period of "speculative tinkering."[8] Feverish might be a more accurate description of the attempts to advance and capitalize on what became a worldwide mania for camera-produced images.

Chemists, painters, dentists, poets, astronomers, botanists— everyone, it seemed—attempted to master "the art of fixing a shadow," as Talbot had called photography. They pioneered many processes based on light-sensitive materials other than silver, including iron (which produced a deep blue image called a *cyanotype*), platinum, palladium, even gold, although gold discolored quickly. Since photography usually involves a two-step process of creating a negative and then using it as a template to create a

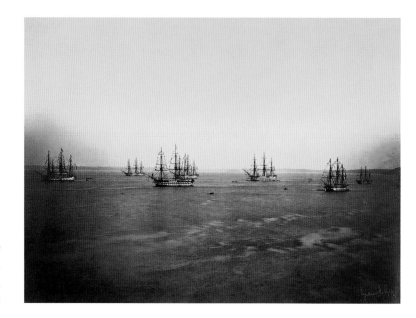

reversed (positive) version, innovation could take place all along the sequence. The variability of paper for both negatives and prints, for example, drove photographers in search of sources suited exactly to particular chemical solutions and producing a particular appearance. Even today, most photographers have a cache of some now-unavailable brand of precoated commercial paper they had the foresight to hoard and place in cold storage. Photographers have even ferreted out the stocks of defunct nineteenth-century paper manufacturers, more valuable than veins of gold to the prospector.

Early photographers developed their images on iron, copper, silver, glass, even thin sheets of mica. They transferred developed emulsion to almost every kind of surface imaginable, including wood, linen, ivory, and leather. It is somewhat surprising that photographic imagery was not more commonly transferred to clothing, but it did grace the human body. At the turn of the century, actress Nina Sherman had the photograph of her fiancé "printed" on her bosom. With each and every innovation, the enterprising originators sought to coin a name and secure a patent. There was Talbot's photogenic drawing and Daguerre's process. There were *anthotypes, chrysotypes, crystalotypes, kallitypes, opalotypes, Woodburytypes*—such a profusion that they were referred to by one exasperated commentator as "humbugotypes."

In many cases, artistic inclinations fueled innovation. Talbot delighted in the variability and range of colors of his "photogenic drawings," even as he strove for consistent and longer-lasting results. By the same token, many of the early pioneers were not concerned with being able to make multiple copies of an image. But such sentiments had little impact on the broader acceptance and adoption of any technique. Just because a process produced

unique or even desirable visual effects didn't mean it would be saved from the scrapheap, and the issue of reproducibility became paramount. Everyone involved in photography, whether dilettante or commercial operator, soon understood that society's hunger for images was only going to grow, and that even a small proprietary piece of the action could potentially yield significant wealth. In 1859, John F. Mascher, inventor of the stereo daguerreotype case, was already eulogizing the daguerreotype in the very act of extolling its unique aesthetic character, a character doomed in part by its one-of-a-kind nature:

> [A] plain daguerreotype picture, alone in my estimation, surpasses in beauty, richness, multiplicity of detail, and intrinsic value, any other kind of picture whatsoever.... Surely [Daguerre's] name is written upon the very pinnacle of the Temple of Fame! and surely, too, the people, during the last few years, have become idolators, and are already returning their homage to the daguerreotype! The fact is, the daguerreotype has become so common, we have forgotten to appreciate its merits.[9]

In a century whose aesthetic was broadly realistic, photography quickly wove itself into the fabric of image-making. But it went further than that, very rapidly. By the turn of the century, photographic self-consciousness was highly developed, among both the population at large and camera artists. Photographic practices displayed a dizzying array of effects, usages, and sensibilities. Pervading so many images—from daguerreotypes of natural events such as eclipses to so-called spirit photographs to F. Holland Day's *Seven Last Words,* a series of staged crucifixion scenes—was an awareness of photography's artificiality, its dis-

tance from "nature."[10] The sense of bordered independence is intrinsic to the perception of any medium or practice as "artistic."

Most of the work was made with technologies since abandoned, like the daguerreotype, each with distinct aesthetic effects and possibilities. The story of what happened to those possibilities and how they have been revived in our time are threads to be taken up later in this narrative. To understand precisely what was lost, however, we can look to another moment when photographic artists surveyed lost possibilities in order to define the "art" of photography. That moment occurred at the beginning of the twentieth century. This first antiquarian avant-garde gave birth to Modernism. The second may give birth to a true photographic Post-Modernism.

## the first antiquarian avant-garde

The Photo-Secession movement of the early 1900s, led by Alfred Stieglitz and Edward Steichen and promoted in the publication *Camera Work,* is widely regarded as the beginning of modern art photography. But it initially faced the future by looking backward. The Photo-Secession declared photography's artistic self-consciousness and independence from documentary reality. In this, it seemed to follow belatedly the pattern of other arts. For decades, painters across Europe had been mounting assaults on academic canons of representation, and by the turn of the century, the foundation of abstraction was already laid. In poetry, Stephan Mallarmé, Jules Laforgue, and the young Guillaume Apollinaire formulated a modern poetic syntax—allusive, hermetic, often syntactically dislocating. Photography, however, looked to its origins.

To declare independence, the Photo-Secession adopted an aesthetic that the members termed Pictorialism, although Pre-Raphaelite might be more accurate. Its models were the distinctly antiquarian images painted by Edward Burne-Jones and others, which were themselves often inspired by the medieval-flavored poems of Tennyson and the Brownings. The Photo-Secession aesthetic eschewed clarity and line in favor of mood and symbolism. It was as if these artists, even as they spoke confidently of a new art, were defending themselves against an old argument by the poet Charles Baudelaire, who saw in photography the herald of a bland, industrialized world:

> If photography is allowed to supplement art in some of its functions, it will soon have supplanted or corrupted it altogether, thanks to the stupidity of the multitude, which is its natural ally. It is time, then, for it to return to its true duty, which is to be the servant of the sciences and the arts—but the very humble servant, like printing or shorthand.... In short, let it be the secretary and clerk of whoever needs an absolute factual exactitude in his profession—up to that point nothing could be better.... But if it be allowed to encroach upon the domain of the impalpable and the imaginary, upon anything whose value depends solely upon the addition of something of a man's soul, then it will be so much the worse for us![11]

Factitiousness, everydayness, the dead priority of merely observed, impersonal, unmediated reality—Baudelaire chose one undeniable element of the photographic complex and saddled the medium with an ontological ball and chain it would drag all the way to the Museum of Modern Art.

More important than its non-naturalistic imagery, the Photo-

Secession proposed photography as a handmade process, linking this essentially industrial mechanism with the arts-and-crafts movement of the late nineteenth century. At least early on, the photograph was a thoroughly material, not necessarily reproducible artifact, and almost any process that emphasized handwork was admitted. The handmade quality of the photograph offered the opportunity to add "something of a man's soul" that Baudelaire considered essential to a work of art. The Photo-Secessionists delighted in printing photographs in *gum bichromate* and *bromoil,* both labor-intensive processes closely akin to printmaking. A single image would be printed over several times to achieve dense, painterly effects. At the same time, *Camera Work* writers and artists set out to establish a lineage of photographic artistry, publishing images by pioneers such as Talbot, David Octavius Hill, and Julia Margaret Cameron, all of whom had been alive in recent memory but whose work was by then largely unconsidered. The past was being reclaimed for a single purpose, the emancipation of an art.

This emphasis on the physical intervention of the artist and his or her control of serendipity (both chemical and temporal), even of reality itself, continues as the fundamental assumption behind the teaching and appreciation of photography. The processes promoted by the Photo-Secession were hardly antiquarian. Most were still too young to be antique, and the technique of *autochrome,* which introduced color photography, was completely innovative. Rather, they were marginal, outside photography's technical and industrial mainstream as it was rapidly developing. Their techniques were not cost-effective in commercial terms and did not serve the market for ever more precise, faithful, and "professional" images. This was, indeed, the first antiquarian avant-garde.

The Photo-Secessionists did not define their art in opposition to painting. That would come later as their own aesthetic changed and they moved away from Pictorialism. Painting's Modernism, its break with realism, which photography itself had furthered, offered the Secession a means of legitimizing its "art." The first antiquarian avant-garde defined itself in opposition not to other arts but to industrial photography, to narrow professionalization, standardization, and technical progress, and especially to photography's use as a mere instrument by almost every sector of society, wherever images were presented and consumed. Just as Baudelaire had written, photography recorded the far-flung possessions and people of empires, documented the latest wonders of science, supplied evidence in police courts, memorialized the dead, and flattered the living. And, increasingly, it sold goods. Art was not supposed to dirty its hands with such things. Lines were drawn between the artist amateur and the industrial professional that have never come down, although they have been redrawn.

The Photo-Secession laid down a pattern and destiny for art photography, from its methods and hierarchy of craft, codified through the workshop, to its mode of transmission via gallery exhibition, to its appropriate avant-garde audience— the happy few, as Stendhal would have put it. Walter Benjamin, one of the most influential theorists of photography, insisted that the advent of mechanically reproduced imagery banished the "aura" of originality from art.[12] Just the opposite occurred. Photographic objects actually acquired the aura of originality. From this point on, lineages commenced, styles became pronounced, and "schools" proliferated as art photography became a distinct category of image making. Over the

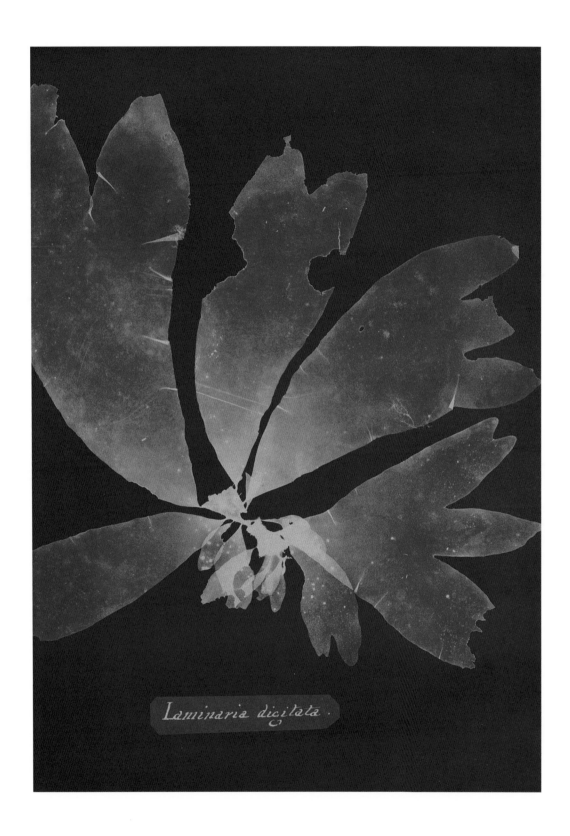

anna atkins
**laminaria digitata**. 1851–54. cyanotype photogram, 10 x 8 inches

decades of the twentieth century, photography's increasing formalism, conditioned by Cubism and Futurism in painting, merged with the documentary intentions of so-called street photography in the work of Henri Cartier-Bresson, André Kertész, and others. The precision of the image corresponded to the precision of the instant. By the time of Garry Winogrand in the early 1960s, a compositional attitude was so deeply ingrained in photographic practice that it appeared to be completely spontaneous. The growing weight of photographic imagery, the consumption of images in every form, from fashion to photojournalism, became so great that it forced open the door of history and promised to end the discussion of the artistic status of photography.

In order for this to happen, however, the very experimentalism and technical diversity of the early Photo-Secession and its antiquarianism was sacrificed on an altar of gelatin silver. The labor-intensive, painting-inspired processes such as gum bichromate and bromoil made less and less sense in a world conditioned by standardized papers and chemicals, more consistent printing techniques, and expectations of clarity fostered by a growing mass media. The evolution of Edward Steichen's formats, for example, shows the triumph of one dominant technique and outlook—that of the gelatin silver print and the "purity" of the image. Painting had proved an inconvenient companion. By this logic of purification, photography defined itself as the complex of camera-world-moment-photographer, severing its analogical ties to painting and discovering its true and independent nature. Paul Strand, a younger member of the Photo-Secession, announced the advent of what would be known as straight photography:

The full potential power of every medium is dependent on the purity of its use, and all attempts at mixture end in such dead things as color-etching, the photographic painting, the gum print, oil print, etc. in which the introduction of hand work and manipulation is merely the expression of an impotent desire to paint.... The existence of the medium is, after all, its absolute justification, if as so many seem to think, it needs one, and all comparison of potentialities is useless and irrelevant.[13]

## ᴠᴀɴɪꜱʜɪɴɢ ʜᴜᴍʙᴜɢᴏᴛʏᴘᴇꜱ

Strand declared the end of an era and a Darwinian triumph. Henceforth the landscape would be cleared of vestigial photographic life forms. In the early decades of the nineteenth century, the desire of Western culture for faithful images of the real world had produced an explosion of approaches and possibilities originating out of the notion of indelibly fixing the action of light. But by 1918, the Photo-Secession, which had initially embraced so many different approaches to photography, ended up repudiating most of them. The vast number of "photographies" that had proliferated since the official "birth" in 1839 were all but gone by World War I. Like the demise of the dinosaurs, the demise of photodiversity represents a loss of astonishing magnitude.

Daguerreotypes, which had been made literally by the millions around the world over the course of just two decades, were almost extinct by 1860. In 1856, Albert Southworth, one of the greatest American daguerreotypists, had trouble selling off his multiple-exposure plate holder. The daguerreotype parlors that once lined lower Broadway in New York City had either closed or converted to other photographic processes. The demise occurred

even though the daguerreotype's ability to render fine detail was—and still is—unsurpassed by any other method. The *calotype* negative, made of thin paper and among the earliest methods of photography, evolved from a soft-edged painterly appearance toward a sharper image with greater precision and tonal range. But it wasn't sharp enough. It was superseded inevitably by materials that offered even greater precision, greater durability, and more consistent results. Wet-plate photography, introduced in 1856, nearly equaled the clarity of the daguerreotype, and the images were reproducible. And yet it, too, was elbowed aside, first by dry glass-plate negatives coated with albumen, which did not have to be exposed and developed immediately, and finally by celluloid roll film, which could register an image at faster speeds and was more convenient to use. The ambrotype (a positive wet-plate image) and the tintype (actually, a coated plate of iron, not tin) only managed to linger because they were cheap, instantly developed, and packageable as keepsakes.

The primary social impetus behind photography was the desire for neutral, accurate renderings of the world, mediated not by an artist's hand but by a machine. That reductive (and commercial) end drove its evolution. Whatever promoted greater accuracy and sensitivity, increased the consistency and quantity of results, improved the durability of the image, lowered the cost, or made picture taking simpler and faster, gained acceptance and opened more territory for photography. Prints made by chemical development after exposure with a negative, for example, replaced prints made by "printing out" in sunlight in contact with a negative because the latter process took too long and exacted too heavy a toll on the original negative. As Weston Naef, curator of photography at the Getty Museum of Art, pointed out in an interview,

"By the 1880s, technology, not expression, became the issue and photography became as common and consistent as white bread."[14]

We are given a vivid glimpse of this technological Darwinism at work in a book documenting the contemporary daguerreotypist Robert Shlaer's own attempt to reconstruct the lost daguerreotypes of the ill-fated John C. Fremont expedition of 1853–54.[15] Before Fremont departed from Kansas City, Shlaer tells us, there occurred a sort of face-off between the daguerreotypist Solomon Nunes Carvalho and a German calotype photographer named Bomer, ostensibly to determine which process might be most suited to the rigors of the expedition. Carvalho, who probably staged the contest, won hands down because the calotypist needed a darkroom and Carvalho had figured a way around it. Ironically, both methods were by then well on their way toward oblivion.

Photography moved inexorably from proliferation toward a standardized set of processes and specifications, as well as a common, consistent repertoire of effects, based almost exclusively on silver iodide chemistry. There are many variations of silver, of course, but once the albumen print gave way to a print coated with an emulsion of gelatin and silver salts, and collodion gave way to celluloid-based roll film in the late 1880s, the tonal values, permanence, and "look" of the modern photograph were established, and nearly every other "look" quickly came to seem antiquated, unreal, specialized, or "impure." First the Photo-Secession and then the Group f64, which included Ansel Adams and Edward Weston, advocated clarity above all, and the growing market for photojournalism, with its imperative to bring the viewer "reality," reinforced the value. As John Szarkowski, the influential photography curator at MoMA, put it, "The new graphic economy that characterizes the best pho-

anonymous
c. 1880s. tintype, 4 ½ x 5 ½ inches

tography of the early years of the century could be described in terms of the conventional concept of composition, but it is perhaps more useful to think of it as the result of a new system of indication, based on the expressive possibilities of detail."[16]

## THE BLACK ARTS

There was one other reason why standardization gained momentum. Early photographers confronted one chemical unknown after another, and many of the materials they handled were potentially hazardous. In the 1850s, photography was called "the black art" because working with silver nitrate, the essential but corrosive ingredient of all silver-based photography, could burn the skin and leave traces of black. The phrase carried other nefarious implications. Stories appeared regularly in nineteenth-century newspapers of explosions, poisonings, and suicides by chemical consumption. The literature of antidotes and cautions was lurid and extensive:

> The deceased was 17 years of age. The evening before her death, she had appeared slightly indisposed....she did her housework as usual, when she was sent by her mistress into the portrait room (immediately adjoining the darkroom where the chemicals were kept) to light the fire. She returned in a few minutes and busied herself getting the tea ready. Her mistress's attention was now attracted by her extraordinary attitude. She stood with a fixed stare, face twitching, and hands hanging down from the wrists as if paralyzed. Her mistress ran to her, caught her in her arms in the act of falling, and put her in an arm chair. Now followed a severe attack of general convulsions, with froth from both the mouth and nose, supposed by witnesses to be an epileptic seizure....She suddenly stiffened her legs, gave a few gasps at long intervals, and died. The attack seems to have lasted about twenty minutes, during which she neither spoke nor screamed....Some additional information was elicited at the inquest, viz., that she had a quarrel with her lover the evening before, and that one of the lumps of cyanide in her master's stock bottle was observed to have recently had a portion broken off.[17]

The culprit in this case was the fixing agent of glass-plate collodion photography, potassium cyanide. This process can be explosive as well as poisonous. The fumes of bromine, iodine, and mercury, the primary chemicals involved in daguerreotypy, are also extremely toxic. Chemical anxiety has been revived along with old techniques, and modern manuals of alternative processes are stamped with almost as many skull-and-crossbones warnings as a nuclear test site.

Of course, so many people were using these processes in the nineteenth century that the dangers became routine. Professional photographers often seemed to approach the hazards with nonchalance, working with silver nitrate and cyanide with their bare hands. More important, an entire industry supported these techniques with tools, supplies, formulae, and shared experience. Much of the guesswork was gradually reduced, and the making of photographs became less perilous as chemicals and processes were replaced or abandoned. In truth, safety has been less of a deterrent to the revival of old-process photography than the wholesale disappearance of an industrial infrastructure. Contemporary artists have not only had to reimagine the past, they have had to reinvent it, too.

## REVOLUTION FROM ABOVE

*The general body of photography is bland, dealing complacently with nature and treating our preconceptions as insights.*[18]

HENRY HOLMES SMITH

By the middle of the 1960s, photography had become the dominant image-producing modality in the world. Leading universities such as Yale had begun to organize photography programs, important galleries in New York and Paris exhibited photography exclusively, and an active department of photography at the Museum of Modern Art was established as the premier center for the collecting and exhibiting of work. The canon of art photographers—camera artists—was being codified in the pages of *Aperture* and other photography magazines, and the aesthetics of photography as a distinct complex of values and assumptions had developed along the lines of Modernist painting and sculpture, with orthodoxies and ruptures, center and fringe. Beaumont Newhall's influential *History of Photography* bestowed a formal trajectory on what otherwise appeared a tangle of usages, events, and ontological uncertainties. There was, after all, something called photography, a distinct art owing nothing, finally, to painting and its various "isms" and liberated as well from its industrial siblings, progressing into new territory according to its own doctrines.

In the view of influential artists such as Ansel Adams, Edward Weston, and Minor White, these doctrines had to do with "composition," "tone values," "form," "style," "mastery," "expressiveness," and "vision." The canon of values did not include techniques that revised the role of the camera, promoted intervention with the negative image after the fact, or allowed materials

an intrusive presence. The token exception who proved the rule was Jerry Uelsmann, a master of seamless visual collage, whose critical reception was a kind of conscience money paid for the neglect of all manipulated photography. Nor did the dominant sense of photography admit the possibility of violating the photograph's surface. Like the canvas in painting, the optical surface of the print guaranteed the artistic object's unity and integrity.

In spite of photography's reproducible, polyglot nature, the dream of the late Photo-Secession was being realized, albeit at a far less exalted financial level than painting and sculpture. And then, as in a bad dream, photography lost its hard-earned aesthetic identity. It was stripped of its autonomy and its silver gelatin skin.

In the mid-1950s, Robert Rauschenberg began to incorporate disparate found materials into the plane of his paintings. Some of that found material was photographic. He called these assemblages "combine paintings." Over the next two decades, photographic imagery would come to play a major role in the cultural and visual drama taking place in the field of these paintings and throughout the fine arts generally. Like rabble admitted to the palace for one day of the year, the ordinary, anonymous, reproducible imagery of journalism and the mass media entered the mythic territory of original, expressive gesture. And once admitted, it was hard to dismiss. The rabble declared that the heroic mythology of painting (explicitly De Kooning's and Pollock's), with its martyrs, legends, and museum temples, no longer corresponded to the nature of things, if it ever had. Likewise, the conception of the expressive gesture (and the artwork) as the bearer of unique and difficult meanings, embodying the soul and psyche of an individual creator, a unifocal vision, was a thing of the past. So, too, was the pathetic fallacy—the attribu-

tion of emotional qualities to things in the world. Art was not autonomous but rather an unprivileged form of data—or "information," as artist Joseph Kosuth would later call it—crowded by signs and meanings from an increasingly image- and commodity-choked world. The artist was not a creator but an organizer, *bricoleur,* harvester of signs.

The impact of such a declaration on the fine arts was extreme. The arrival of Pop Art banished the mythic from art and replaced it with ironic, astute, culturally complicated statements of an unclassifiable character. A painting was no longer a painting, certainly not a modern totem, or even an object as such but a locus of events, a kind of spectacle. The impact on photography was less obvious but in the long run even more profound. Photography's insertion into the space of painting transformed it into the tool of a self-conscious, critical avant-garde, with all of culture as its subject. Never had photography been marshaled to such a comprehensive task, not even by the Bauhaus with its credo of "new objectivity" and its goal of social transformation. In the process, however, photography was turned against its own artistic aspirations. In truth, the "art of fixing a shadow" had no true language of its own. It quoted from the world and was dependent on observed reality. Its status as an autonomous "art" was always borrowed, provisional, and contingent on the definitions of the other arts. The correspondence between emotional states and selective images, which Stieglitz had first proposed as the foundation of art photography, was severed for photography and for all of art. First Rauschenberg, then Sigmar Polke in Germany, and finally Andy Warhol and the entire Pop Art movement reimplicated photography in the leveling of cultural hierarchies, reattached it to its factitious, commercial, and reportorial roots, and commandeered it for a variety of anti-artistic purposes, including the criticism of art as expressive form.

Conceptual artists focused directly on the documentary nature of photography as the source of its identity and hegemony in the world of images and in the transmission of culture. Whatever photographers might think, whatever claims they might make for its expressive autonomy, in the view of conceptual artists, photography could not be divorced from its subjects and its occasions, as painting had long ago managed to do. They could not have cared less for gray scales and tone values. Photographic images were constructed of signs, and signs were culturally determined. Douglas Heubler, Bruce Nauman, John Baldessari, Dan Graham, Victor Burgin, Robert Smithson, and other artists created elaborate documentary records of evanescent, trivial, and even spurious events—Smithson's *Tour of the Monuments of Passaic,* for example, or Nauman's failing to levitate himself. The targets for such deconstructive acts might be anything from the art exhibition to the imagery of advertising. The cumulative impact was to undermine not only the "documentariness" of the camera image but also its putative expressiveness. At its best, the photograph was an object of belated significance. At its worst, it was a tool of oppression. Artists such as Adrian Piper and Eleanor Antin laid bare photography's political role in fostering stereotypes and social inequities. The gendered mass media provocations of Barbara Kruger are a direct descendent of conceptual art's image scrutiny. Subjectivity and form, the watchwords of fine art photography, got caught in the crossfire.

So, too, did the notions of photographic competence and the sensuousness of a uniform photographic surface. In 1963, Edward Ruscha assembled his series of deliberately deadpan

photographs, *Twenty-Six Gas Stations.* Commenting ironically on Walker Evans's spare signature style, Ruscha took photography out of the hands of the "masters" and gave it to no one. The banality of his images made the camera once again anonymous as it had not been for a century.

Warhol, appropriately, added a final touch, with help from artists such as Polke, Robert Stanley, and Chuck Close. These artists transplanted the photograph into other soil, into painting and silkscreen. Polke experimented aggressively with the possibilities of photographic chemistry and exploded the apparent unity of the image and its ingredients. Material competed with and often overwhelmed representation of the subject. The idea of the anecdotal photographic image and its cultural implications might survive, but its surface, look, authority, and immediacy dissolved into Benday dots and pigment. These artists created pictures that exist in what critic Klaus Honnef has called "an inter-media sphere" no longer subject to the parameters of conventional aesthetics.[19] How could a photograph be an aesthetic object when it was no longer even a thing, or was a different kind of thing from what it was when it began?

What was photography? By the 1970s, the question had not been so open and unavoidable since the time of William Henry Fox Talbot. In photographer Jeff Wall's words, "Photography could emerge socially as art only at the moment when its aesthetic presuppositions seemed to be undergoing a withering radical critique, a critique apparently aimed at foreclosing any further aestheticization or 'artification' of the medium. Photo-conceptualism led the way toward the complete acceptance of photography as an art.... by insisting that this medium might be privileged to be the negation of that whole idea."[20]

Talk about a Pyrrhic victory. The art of the 1960s and 1970s extended the so-called crisis of the image to the last outpost of representation. In the process, it engendered most of the current strategies in photography. Photography began to give up its formal preoccupations and stylistic imperatives in favor of cultural criticism and intellectual program. This identity for photography, represented on the one hand by Sherrie Levine's unabashed appropriations of classic photographic images and on the other by Cindy Sherman's *Untitled Film Stills* series, dominates the image making of our time.

Yet the postmodern challenge to art liberated other photographic possibilities always inherent within the medium. As he was beginning his combine paintings, Robert Rauschenberg was also experimenting with photograms and cyanotypes, two of the most primitive forms of photography. Like Edward Steichen before him, he was looking forward by looking backward.

Today can and should be a time for those interested in the visual image possible through photography to advance the quality of this imagery by turning back to the techniques of the past.... I appeal for a critical reevaluation of the discarded techniques of photography to enhance the images of the future.[21]

ART SINSABAUGH

## SHEDDING THE SILVER SKIN

In 1963, photographer Art Sinsabaugh was a voice crying in the wilderness, but he soon became a prophet. The same impulse that drove Robert Rauschenberg to make photograms and cyanotypes—to explore what photography was in its most basic form in order to understand the implications of its appropriation—also drove many artists toward what Stieglitz had long before referred to as "crooked" photography. In 1973, an exhibition organized by the Hudson River Museum presented a lineup of the crooked, if not twisted. "Light and Lens" was organized with the help of Museum of Modern Art curator Robert Longwell, but most of the exhibition contributors were not likely to be given retrospective exhibitions there. Robert Fichter revived the cyanotype and updated it with Florida imagery out of Ed Ruscha's repertoire of roadside signage. Betty Hahn, then at the Rochester Institute of Technology and in the orbit of the George Eastman House Museum of Photography, used gum bichromate, the anathematized painterly material of the early Photo-Secession, to create a sequence of images that seemed to hover between reportage and home movies. The images managed to suggest at once the nineteenth-century motion studies of Eadweard Muybridge, contemporary street photography, and collage. Van Deren Coke, author of a history of the relation between painting and photography, manipulated an image of an antique ambrotype to suggest themes that would become central to the antiquarian avant-garde—memory, decay, and accident. For all these artists, the referential character of the photograph was just a point of departure.

It is easy to see why such work, often coming out of conventional photography programs, fomented discord. It was one thing to contest what was regarded as acceptable content in images. That had been going on in Western art for centuries. These artists, on the other hand, with Warhol's permission, proposed to strip the photograph of its gelatin silver skin, to sacrifice its luminosity, its silver trace of light,

its transparent essence, in the pursuit of a wider range of effects. They sought to turn the photograph back into a three-dimensional object. Sacrilege is not too strong a word to apply to their practices.

As a graduate student in the early 1970s, Bea Nettles encountered outright resistance when she began to experiment with alternative processes and media. Nettles was banned from the darkroom when she used a sewing machine to stitch together photographs and paintings on fabric. As her teacher Betty Hahn had done before her, Nettles was carrying into the darkroom, with all its associations of occult knowledge and male fellowship, a domestic female machine, with distinctly art-less associations. Some of the disapproval, she felt, was inspired by the fact that she was a woman entering a man's province. Gum bichromate, so close to the ancillary art of printmaking, was seen as women's work, impure and unphotographic, "tits on a bull," as one photographer remarked.

Bea Nettles did something about this. She published a compendium of alternative approaches to photography entitled *Breaking the Rules: A Photo Media Cookbook*. It was followed in 1980 by William Crawford's *The Keepers of Light,* the first comprehensive summary of antique photographic processes and instructions on how to re-create them. A decade earlier, *The Silver Sunbeam,* an important nineteenth-century manual, had been reprinted, but it was not easily obtainable. Likewise, Joel Snyder had given sketchy instructions on how to make everything from a daguerreotype to a paper negative in the TIME-LIFE volume *Light and Film,* but these forays were clearly novelties, nothing any real photographer would pursue except as a masochistic exercise.

By the late 1970s, however, influential photographers including Nathan Lyons and Henry Holmes Smith were already engaged in teaching alternative techniques. Programs and workshops were going strong at the Rochester Institute of Technology and the

**BETTY HAHN**
**inner rainbow.** 1968. gum bichromate, 22 x 14 inches

University of New Mexico, among other venues. When Betty Hahn secured a faculty appointment at Rochester in 1970, she took over the position previously occupied by Minor White, the founder of *Aperture* magazine. Says photographer and teacher Christopher James, "*Keepers* and other publications were more like permission slips than guides. When it comes right down to it, all of us have had to teach ourselves or learn directly from others."[22] That caveat has not stopped James from writing what may be the most extensive manual on the subject, *The Book of Alternative Photographic Processes.*

In the overthrow of art and photography, others were seeking the same permission. In 1969, Eric Renner founded the *Pinhole Journal,* dedicated to promoting the most primitive type of camera. It seemed as much a political as an artistic act. Renner was advocating a photographic "back to the land" movement, through the abandonment of the increasingly elaborate technology of the lens. The *pinhole camera* is simply a chamber with a pinhole to admit light (the historical *camera obscura*) and a piece of film to capture the image transmitted through the pinhole. The chamber can be any size, and the "film" any light-sensitized material. Under the influence of the *Pinhole Journal,* photographers around the world have converted everything from tin cans to trailers into cameras. Englishman Steven Pippin has even turned railcar toilets and Laundromat washing machines into cameras. Images made with a pinhole are anti-art in more ways than one. They are as much a record of the process of making a photograph as they are a representation of reality.

In 1976 a peculiar gathering took place at the home of Harvey Zucker in Staten Island. The group included photographers, chemists, collectors, and hobbyists, most of whom would qualify as, at best, amateur picture makers. Like conspirators at the beginning of revolution, they seemed slightly puzzled at what they hoped to accomplish, but they had a clear idea of what they had in common:

they all made daguerreotypes. Of all the photographic processes, this was the most antiquated and arcane. Its entire world had disappeared, from the equipment to the material medium itself, silver-coated copper plate. Few of the people in the room made their pieces as art, but they all were attracted to the properties that originally had made the medium so popular: its luminescence and ability to render detail. What may have looked realistic to nineteenth-century eyes now looked surreal, if not supernatural.

Irving Pobboravsky was not at that gathering, but he had already written and published his master's thesis on the chemistry of the daguerreotype, a document familiar to the "conspirators." He remarked, "I was always under the impression that photography had steadily advanced from the nineteenth century. Then I saw my first daguerreotype, with its tones, sharpness, and presence, and I knew the idea of progress was false. The daguerreotype is a magic window that transforms the world it presents."[23] The group had gathered in Staten Island, above all, to write themselves a permission slip to open that magic window. A year later, many of the daguerreotypists became artists willy-nilly, when Grant Romer, himself a budding practitioner and photographic historian at the George Eastman House, organized an exhibition of contemporary daguerreotypes. The antiquarian avant-garde had no true birthday, but this was its christening.

Over the next two decades, permission slips to the world of nineteenth-century photography were issued from unexpected quarters. A group of influential critics conditioned by conceptual art and Surrealism developed a comprehensive critique of the "ideology" of photography, especially nineteenth-century images, using the terms set by French cultural theoreticians Michel Foucault, Jacques Derrida, and Jean Baudrillard, and by Walter Benjamin, whose theory of art and mechanical reproduction,

advanced in the 1930s, became a kind of mantra. First Susan Sontag, then Geoffrey Batchen, Jonathan Crary, Hal Foster, Abigail Solomon-Godeau, Shelly Rice, Alan Sekula, and others sought to "deconstruct" every aspect of photography from the act of seeing (and being seen) to the idea of beauty. The romantic nostalgia of early photography evaporated in this critical heat, leaving an unsightly silver stain. To take one instance, it is difficult to ignore the role of photography in documenting Duchenne de Boulogne's 1860s experiments using electric shock to manipulate the facial muscles of nonconsenting psychiatric subjects. In spite of Jacques-Henri Lartigue, Lewis Hine, Robert Capa, and all the other humanists of the camera, such visual records seem to implicate every photograph as an act of moral distancing.[24] These records also identify photography with a view of science as a denial of human subjectivity, a theme that occurs repeatedly in works of contemporary photographers.

This withering examination could hardly be said to sanction old-process work, but it helped make nineteenth-century images visually and intellectually available to artists. It also drew renewed attention to photography as an historic art. As money poured into the art market in the 1980s, so-called primitive photography was relegitimized as art object, with its own arcana of authentication and provenance, and collections that had been assembled privately gained public visibility. Prices on vintage photographs and the frequency of their display began to skyrocket. It became possible to see work of every genre, much of it not displayed for over a century, at galleries and museums across the country. The George Eastman House, with its vast archive, mounted exhibition after exhibition of vintage work. Historians and curators such as Grant Romer, Weston Naef, Robert Sobieszek, and Gail Buckland brought the genres and artists of early photography out of the storage rooms. The history of photography itself, long the exclusive province of Newhall, the director of George Eastman House, admitted other narrators, and names that were either unknown or obscure began their ascent to the art pantheon: the French calotypists Henri Le Secq, Gustave Le Gray, Hyppolite Bayard, and Charles Negre; portraitists Nadar, David Octavius Hill and Robert Adamson, Julia Margaret Cameron, and Lewis Carroll; daguerreotypists Albert Southworth and Josiah Hawes; and travel and landscape photographers such as Timothy O' Sullivan, Felice Beato, and Francis Frith.

Artists conditioned by deconstruction theory seized opportunities to link early photographs to contemporary concerns about political power, control of the body, and the social construction of reality. In the late 1980s, for example, Warren Neidich cast a cold and clever eye on the supposedly neutral historical archive and its reinforcement of power relations by creating several spurious collections of albumen prints.[25] One series presented views of African Americans that would never have been available in the nineteenth century, then showed how cropping could alter their impact even further. The images included well-dressed rural black families on their way to church and hunting scenes in which it is clear the white men with rifles and pistols are not pursuing animals.

The use of images to critique a culture mediated by images gave permission to Cindy Sherman and Sherrie Levine, to reductive strains of antiphotography interested primarily in the "text" of the image. At the same time, however, it also opened up a fund of metaphors and techniques that could be used to "problematize" the physical and aesthetic aspects of photography, and even the medium of light itself. Nostalgia would be in the eye of the beholder, and beauty, too, if and when the word could be acknowledged.

In fact, every photograph is a fake from start to finish, a purely impersonal, unmanipulated photograph being practically impossible. When all is said, it still remains a matter of degree and ability.

SOME day there may be invented a machine that needs but to be wound up and sent roaming o'er hill and dale, through fields and meadows, by babbling brooks and shady woods — in short, a machine that will discriminatingly select its subject and by means of a skillful arrangement of springs and screws, compose its motif, expose the plate, develop, print, and even mount and frame the result of its excursion, so that there will remain nothing for us to do but to send it to the Royal Photographic Society's exhibition and gratefully to receive the "Royal Medal."

THEN, ye wise men; ye jabbering button-pushers! Then shall ye indeed make merry, offering incense and sacrifice upon the only original altar of true photography. Then shall the fakers slink off in dismay into the "inky blackness" of their prints.[26]

EDWARD STEICHEN

Epiphanies leave a certain deadness in the air. We wonder, has anything really changed?[27]                    IHAB HASSAN

As with other arts, the postmodern transformation of photography involves the conscious embrace of all its valences, an embrace not possible until now. Photography acquires a formal history and perhaps a distinct province at the moment it becomes fully self-critical, a process that began with the Photo-Secession and has now reached a high-water point. This process, Hegelian in its momentum and contour, is enacted by artists in an encounter with both the historical situation and the materials of photography—light, metals, paper, chemicals. Its intention is the material embodiment of ideas. For the antiquarian avant-garde, and for all photographers, the past is available, demanding, and problematic, and the art produced is self-aware. It can also be joyful, meticulous, sensual, imitative, antagonistic, and reverential. What it cannot be is naïve.

To paraphrase the philosopher Heraclitus, it is impossible to step into the same river twice. Artists can only choose such processes as options, as arguments against a reductive ideology of the photographic image and the art object. What the artists of the antiquarian avant-garde seek is the most fruitful play between past associations and current intuitions.

Again, this play necessarily involves an examination of materials and formats. The cyanotype's blue color probably has no intrinsic significance; however, it does have distinct physical properties that can be marshaled in the context of an image, properties that can suggest historical and emotional associations, accentuate formal relations, and make the familiar strange. Daguerreotypes cast a more subtle and exacting spell. Jerry Spagnoli has insisted that because of the way a daguerreotype is viewed—as light reflected back through the image itself—it constitutes an optical system, not a photograph. In his view, the process of viewing the image directly repeats the original act of photographic seeing and registration. Existentially speaking, the past is recaptured.

Many photographers working today in old processes express the same intense desire to recover the hand-made quality of images, even though the outcome of their labor is reproducible on a mass scale. A conventional 35mm negative can be used to produce a daguerreotype, tintype, ambrotype, albumen print—practically any kind of photographic format imaginable—in quantity. Yet, in the words of Mark Osterman, who makes wet-

plate collodion images on glass, "When you look at an early process like collodion, you can see the photographer's fingerprint, so to speak—how the plate was held and the collodion poured onto it and swirled. Likewise, no two prints were ever exactly alike."[28]

Contemporary artists use the ways of seeing embodied in each process as the pigment and the substance of their art. We come close to arguing that each process has its own appropriate images, or at least that subjects are not translatable from one format to another. Form, vehicle, and content unite in an indissoluble physical object, not just a two-dimensional representation. Of course, the daguerreotype, tintype, and ambrotype can be used as printing media, rather than being created "in camera" as one-of-a-kind objects. At first sight this seems cheating, a kind of "mongrelization," to borrow a term from photographer Brett Weston. Practically, however, the results of any process are unpredictable and often revelatory. A daguerreotype made from a transparency by Adam Fuss, or an ambrotype made similarly by Luis Gonzalez Palma, is a three-dimensional object, inevitably different from all its sister object-images, no matter how consistent the processing. The individual outcome of these processes is what attracted Jayne Hinds Bidaut to the tintype. It struck her as a way of overcoming the anonymity of images, of rematerializing and humanizing photography, so that today it might be approached with the same sensuality and thrill of possession as it was 160 years ago.

GHOSTS IN THE FRAME

In a time of critique and resurrection for photography, the nineteenth century supplies metaphors and kindles fascination. The representative figures of early photography, especially Talbot, Bayard, Le Gray, and Daguerre, provide an archive of visual quotations that no longer seem distant or arcane. Severed from the world they depicted, the images seem to call to us from a place outside time with preternatural intimations of our moment.

Photography arose at the junction of science and self-expression, with clear overtones of a will to control nature and reality. Part two of Goethe's *Faust* was completed just years before the announcement of photography. It was the time of inventory and catalogue, of classification and objectification. Many of the artists using old processes today focus on such inventories as emblems of modern scientific consciousness. Gábor Kerekes's images of confected primitive scientific equipment and his salt prints of fossils, recalling both Talbot and Daguerre, present a vision of science as a poetic enterprise, with the potential for aesthetic wonder and monstrous violation.

In contemporary imagery, photography itself appears as an elaborate parlor trick—or is it a true summoning of spirits? Dan Estabrook and Stephen Berkman play on the staginess of early photographs, quoting from images and suggesting deceptions of an obscure intention. Estabrook suspends a blank cloth by clearly visible wires. Berkman presents a series of collodion images of two men in top hats carefully carrying a third in a chair across a stage. The spurious record of an unfathomable event, it recalls the stiffness and formality of Talbot's photographs of top-hatted gentleman shaking hands and taking tea at Lacock Abbey. Mark Osterman uses the technique of so-called spirit photography, which is the creation of a "ghost" image by moving a subject in and out of the frame during a long exposure. Spirit photographs purported to show what could not be seen, the aura of the departed. Osterman's collodion ghosts are meant to suggest the opposite, that photographs actually

CHRISTOPHER JAMES
**drivers/giza.** 1992. plastic camera negative,
salt print, 11 x 8 ½ inches

miss what is essential about reality, showing only an elaborate fabrication. The truth, he suggests, is in the trace, the telltale evidence of human intervention.

Perhaps the most pervasive legacy of nineteenth-century imagery is anatomical. Body parts, fragments, and skeletons show up in the developing trays of contemporary artists with alarming frequency, from the full frontal torsos of Chuck Close's portraits to the single closed eye of Australian Mark Kessell's daguerreotype self-portrait, to the disembodied hands, arms, feet, and other extremities that appear in work by many other artists, including Jerry Spagnoli, Kerekes, and Estabrook. Sally Mann has made collodion images not only of the skeletal remains of a pet dog but also of corpses in various states of decay at the FBI's forensic research facility, the so-called Body Farm. It is as if today's artists work not in darkrooms but in anatomy labs or operating rooms.

Early photography is crowded with anatomical imagery, with Talbot's hand studies being perhaps the earliest and most suggestive. The growth of a vast clinical archive included gruesome and extensive evidence of dismemberment, decapitation, and death, ranging from Felice Beato's panoramas of slaughter in India in the 1850s to an anonymous photograph of a pile of amputated limbs in a Civil War surgical tent. Such images mark a progress described by philosopher Michel Foucault in which social institutions increasingly objectified, investigated, catalogued, and administered the body and its functions, with photography as the handmaiden of this depersonalizing process. In the current context, images such as Estabrook's can also be read as a nostalgia for immanence in a materialist world, a search for evidence of some principle that might unite matter and spirit, or to borrow one of his preoccupations, positive and negative.

Whose body is it, then, divided and dispersed, if not also the body of photography itself? The tentative unity and identity of photographic art has dissolved into fragments, components, fundamental elements, and the seeing eye turns its gaze on the means of seeing. Returning to photography's origins, artists such as Susan Derges, Ellen Carey, Susan Rankaitis, and Bruce McKaig explore sometimes imageless realms of light and dark. Rid of the camera, they gather the merest yet most direct evidence of light, the precondition for any more elaborate record of time, place, and presence that is—or was—a photograph. Ellen Carey calls this new minimalism "photography degree zero," echoing Roland Barthes's celebration of the "death of the author" in modern literature.[29] In the process of reduction, this art appears to do away as well with the photographer, and to banish the artist's conscious intention in favor of accident and chance.

Some seven decades ago, Marcel Duchamp, inspired by the impersonality of photography, imagined just such a fate for all of art. But as with minimalist painting, photography degree zero posits not the end of photography but a new class of photographic objects, fully free of the responsibility and limitations of representing the world and the moment—free also, perhaps, to enter into a new relationship with the spectator. As Duchamp remarked in a 1957 talk about the creative act, the artist acts "like a mediumistic being who, from the labyrinth beyond time and space, seeks his way out to a clearing." And the audience plays an essential role in realizing the work of art: "The spectator brings the work in contact with the external world by deciphering . . . its inner qualifications."[30] A clearing is a place where light falls openly and sight is renewed. Such a clearing was opened at photography's birth, and artists of the antiquarian avant-garde are tracing a new path toward it.

Oliver Wendell Holmes, Supreme Court justice, light verse writer, and photography's first great critic, called the daguerreotype "a mirror with a memory." There is no better metaphor for the precise and detailed images rendered on polished silver plate that was photography's first publicly demonstrated process. But a mirror of what, bearing traces of whose memory? The photographer's? The viewer's, who had to shift the shiny surface of the plate in order to glimpse an image unobscured by his own reflection? Society's? Nature's? Can nature or a camera have a memory?

From the first, the daguerreotype reflected photography's own impossibility, its near immateriality. It mirrored, in the viewer's reflected image, photography's origin not in nature or cold scientific experiment but in an entire society's shared desire for another way of seeing, for vision more fastidious and permanent than human sight. Yet the most faithful of all photographic forms is also the most illusory, the most difficult actually to see. More than a record, the daguerreotype is a resurrection—not of the subject but of the original act of seeing.

The story of how Louis Jacques Mandé Daguerre laid claim to the invention of photography in 1839 is well known, although his title to priority is still debated by historians. The painter and impresario, whose 360-degree painted dioramas mesmerized Paris, sought the total visual art form, the unsurpassable representation of nature that would leave nothing out and draw everyone in. He exhausted all the photographic precursors, including the camera obscura, which captures and projects images but does not fix them, and the moving diorama. He collaborated at first with Nicéphore Niépce, an artist-scientist much further advanced in "heliography," as he called it. Indeed, Niépce had already made a photograph on pewter plate. After he died, Daguerre appropriated his collaborator's work, wiping away Niépce's contribution by coining the name

"daguerreotype." He announced his invention to the scientific and artistic communities in a coup de théâtre, showing all and telling little. Daguerre may have wanted the respect of art and science, but he wanted the awe of Everyman, the masses, whom he was convinced would make his fortune. His process took dominion not just in the studio and the laboratory but also in the street.

The daguerreotype was somewhat laborious to make and difficult to view, but it proliferated into the millions. Its beauty was extolled beyond measure. "Their exquisite perfection transcends the bounds of sober belief," crowed one commentator.[31] The cumbersome cameras sold like hotcakes as painters laid aside their brushes and chemists their retorts to become "daguerrean operators," as they were called. The daguerreotype even prompted *The New Yorker* to exhort, "Steel engravers, copper engravers and etchers, drink up your aquafortis and die!... All nature shall paint herself."[32] It created new industries and buried others, miniature painting, for one. The process brought amazement and a remodeling of sensibility. It moved Ralph Waldo Emerson to declare the time "an ocular age." A daguerreotypist was even elevated to the status of a literary protagonist in Nathaniel Hawthorne's novel *House of the Seven Gables*.

And then, almost overnight, the daguerreotype was gone.

In less than a decade, from the late 1850s to the late 1860s, daguerreotype parlors converted to glass-plate photography or closed. In New York City alone, the change affected dozens of studios, and none was spared, not even the most celebrated. In 1854, Mathew Brady published a notice justifying the high prices of his daguerreotypes based on his ambition "to vindicate true art and leave the community to decide whether it is better to encourage real excellence or its opposite."[33] The community quickly decided. One year later, he was offering glass-plate ambrotypes, a competing process. Well before 1870, commercial

activity had all but ceased in this once globally distributed technology. By the turn of the century, the daguerreotype was already a curiosity, almost a relic, a keepsake relegated to mantelpieces and curio tables. Looking at these objects today, it is difficult to understand why they were so categorically dismissed—or why anyone would have thought to revive them once they lost favor.

The daguerreotype transmogrifies the world in transcribing it. It offers something more than a copy of reality—sight without limit. The closer you look, the more you see. In this regard, the daguerreotype is both pitiless and ennobling. Its power is the power of absolute surprise, a power that, unlike every other photographic medium, seems not to diminish with the number of times the image is regarded. The daguerreotype is sui generis, and for this reason did not completely disappear even though its commercial value plummeted. "What a strange effect, this silvery glimmer and mirror-like sheen!" wrote photographer Sadakichi Hartman in 1912.[34] Like Aladdin's tarnished lamp, the daguerreotype could sit on the technological scrap heap, and someone would always happen by to rub it and release its genie.

That genie is a unique visual experience, somewhere between document and original perception. The daguerreotype is made by rendering a silver-coated copper plate light-sensitive with the fumes of bromine and iodine, then exposing it in a camera, developing it with a vapor of mercury, and fixing it in a bath of hyposulfite to remove the excess silver halides. The finished plate is treated with gold chloride to preserve the image. The process produces a one-of-a-kind positive image, rather than a negative that then becomes a template for a positive. Since the image comes through the lens reversed, it appears reversed on the plate. Unlike early paper photographs, the exposed, brilliant silver grains sit up on the plate, instead of sinking into the vegetable fibers. And unlike later paper

photographs, the silver is not suspended in a solution of albumen or gelatin. Rather than being absorbed, light actually passes around the image and is then reflected back up through it to the viewer. This accounts in part for the depth of the image, as well as for its direct positive character. The angle of viewing has to be just right in order to retrieve the image from the reflected light. Placing a black field opposite or above the image makes viewing easier by cutting down the amount of reflected light.

With hindsight, we can solve the mystery of the daguerreotype's disappearance. A daguerreotype image could not be reproduced and so had limited commercial appeal for a world that demanded images for mass communication and education. It was far costlier to make than a glass-plate positive (an ambrotype) or an albumen paper print from a glass negative, which could itself provide much of the detail of a daguerreotype. Above all, the daguerreotype could not be casually sampled. It had to be intimately engaged and experienced, and that took time, a commodity increasingly luxurious in the developing industrial world of the West. Indeed, for most of the emerging documentary and journalistic functions of photography, the daguerreotype was cumbersome if not unsuitable.

Once the daguerreotype lost its luster, it was difficult to see, culturally speaking. As Hartman remarks, it became a curio, but always there were enthusiasts and artists fascinated enough to look, even if looking rarely translated into making—which would have been an act without social meaning, an art without an audience. Grant Romer, director of conservation at George Eastman House, has written the interim history of the daguerreotype, a history of dabbling in a void.[35] After the supporting industries, especially plate production, disappeared, the techniques and materials had to be reconstituted, the wheel reinvented, with each experiment. With no community of craft, knowledge went nowhere.

That situation began to change in the 1960s when Irving Pobboravsky of the Rochester Institute of Technology conducted chemical research on the nature and effects of the daguerreotype. His curiosity was more than scientific. He found daguerreotypes so intrinsically beautiful that he wanted passionately to make them. In the early 1970s, Walter Johnson, another enthusiast, founded the *New Daguerrean Journal,* and the handful of people making "dags," as they are called, began to congregate with people collecting them, creating a feedback loop. As if the clock had been turned back 140 years, old manuals were unearthed and experiments proliferated. Mark Stebbins succeeded in making a daguerreotype image on an old half-dollar coin, ideal because of its high silver content. The Rochester Institute of Technology and the historical collections of George Eastman House Museum made Rochester into a pivotal location, where the stone was rolled away from the tomb, so to speak. Romer, Pobboravsky, and Stebbins reinvented methods and made images, and Romer organized the first exhibition of modern daguerreotypes. In 1988, Romer, the writer John Wood, and others founded the Daguerrean Society, and a true artistic nucleus was formed.

Each artist, from Irving Pobboravsky to Chuck Close, has had to make a leap from curiosity to commitment, to see the medium as a form of expression meaningful enough to invest in despite inevitable failure and frustration. Daguerreotype images hover. They seem to move with a kind of animation and even change colors. This gives portraits in particular the uncanny quality of life-in-death, a presence and dimension. If, as photographer Jerry Spagnoli insists, viewing a daguerreotype approximates the photographic event itself, the original act of seeing, then a daguerreotype is a kind of virtual reality time travel.

Spagnoli's work explores the domain of this virtual reality. He began his career as a conventional photographer and became interested in the parameters of information in the so-called documentary photograph. He wondered how much definition the tiniest figures in his images actually contained and began to shoot subjects at long distances—across baseball stadiums, for example. When he enlarged them, he found that a human figure might be "read" from no more than a few grains of deposited silver. At such a point, the figures became conjurations, their gestures mysterious and vague, but unmistakably human. He was at the limit of the photographically visible. He wanted to cross that boundary into a new territory of visual information, and the daguerreotype offered a way. Once he satisfied himself that daguerreotypes could be made safely, he largely abandoned conventional photography.

In his recent collaboration with Chuck Close on a series of nude studies, Spagnoli has assumed the role of the nineteenth-century daguerrean operator, providing technical assistance. Yet this background role is misleading. Both Spagnoli and Close share a desire to define new subjects and transcend the daguerreotype's apparent incongruousness. Watching the two of them work is to step back into a world of hands-on artistry but with a contemporary conceptual edge. While Close directs the arrangement of the model against a black background cloth, Spagnoli polishes the plates with a long buffing stick coated with fine red polishing powder. He disappears into a small darkroom to sensitize the plates. The camera is a large-format, wooden machine with a fixed lens and a cloth hood. Spagnoli built most of his equipment, including the container for mercury developing. The fumes are highly toxic. There is another, less perilous, developing process, called the Becquerel method, which has been revived by Gerard Meegan. It involves covering the exposed plate with a red or yellow filter and letting it develop in daylight. Becquerel plates inevitably acquire a

tinge of color, from green to yellow, and the images tend to appear flatter than with a mercury-treated plate.

In the finished daguerreotypes, old and new collide. After developing, the images emerge gradually like ghosts caught unawares in daylight. Shiny, light-reflecting surfaces such as jewelry and fingernails appear first, then the rest of the body. The images hint at another reason the daguerreotype may have run its course: It is too realistic. Its information is relentless, impossible to limit. We can sympathize with the poet of 1841 who wrote of the daguerreotype, "Truth is unpleasant / to prince and to peasant."[36] By comparison, most nineteenth-century photographic nudes have a soft, sculptural quality, closer in spirit to Fragonard and Boucher. The studies of Close and Spagnoli embody a dispassionate attitude that only augments the daguerreotype's unblinking regard.

If both Close and Spagnoli seek to heighten what they see as the documentary essence of the daguerreotype, Adam Fuss and Mark Kessell seek to challenge and reframe the reflection. Kessell's portraits select a fragment of the subject, breaking down nineteenth-century unities of perspective and identity. Kessell focuses the daguerreotype's detail selectively, on an eye or a hand, for instance, letting the rest go out of focus and solarize in specific areas. He often assembles multiple images into a whole, which is itself still only a fragment of a subject. Kessell was trained as a physician, and like so many early daguerreotypists, he brings a sensibility conditioned by science, a sensibility without nostalgia and avid for discovery. Yet the images he produces sacrifice objectivity in favor of expressive gesture and metaphor.

Adam Fuss's series, *My Ghost,* begun in the 1990s, was inspired on the one hand by his viewing of contemporary daguerreotypes by Robert Shlaer and on the other by the poems of

Arseniy Tarkovsky, father of the Russian film director Andrei Tarkovsky. This series challenges many assumptions about the daguerrotype, including its clarity. Fuss courts blemish and imprecision in the pursuit of images that emphasize the play of light and color. Like the French daguerreotypist Patrick Bailly-Maitre-Grand, Fuss makes his daguerreotypes "out of the camera," from images on film, and uses the plates as a field of visual experiment.

It is the daguerreotype's classic character, its high degree of definition, that best suits Fuss's most striking departure, the presentation of text in daguerreotype. He has photographed pages of a mystical love poem, "First Meetings," and used the images to make the daguerreotypes. The letters of Tarkovsky's ecstatic poem appear at once graven and ethereal, eternal and effaceable. Just as William Blake found in engraving an ideal medium to convey the palpable reality of prophetic vision, Fuss has found in the daguerreotype an ideal vehicle for conveying the simultaneous presence and absence of words and the universalizing light of mystical awareness.

Metaphorically, art brings light to the world. The idea is as old as Plato, who distrusted it, and as current as artists such as Dan Flavin, James Turrell, Jenny Holzer, Nam June Paik, and Bruce Nauman, who have all taken this metaphor as their starting point. The daguerreotype literalizes the metaphor. Its "material" is light's instant; the intimation it seeks is of light's immortality. One step closer to the original source of light than a photograph on paper, it solicits our participation in a repeating spectacle, always the same, always original in the instant of our viewing. The mirror with a memory offers a peculiar transcendence, of moments glimpsed inside and outside of time. It is as if the daguerreotype, in being seen, were somehow seeing us.

aLejandro martinez

1 **la cámera de dario**. 2000. daguerreotype, 2 ½ x 2 ½ inches

2 **cabeza**. 2000. daguerreotype, 2 ½ x 2 ½ inches

1

2

PATRICK BAILLY-MAITRE-GRAND

1 **la porte**. 1984. daguerreotype, 5 x 4 inches

2 **la lune**. 1988. daguerreotype installation, six plates, 8 x 12 inches each

1

IRVING POBBORAVSKY

1 **untitled**. 1989. daguerreotype, 4 x 5 inches

2 **great wellesville hot air balloon rally**. 1981. daguerreotype, 4 x 5 inches

2

CHUCK CLOSE
**self-portrait**. 2000. daguerreotype, 10 x 8 inches

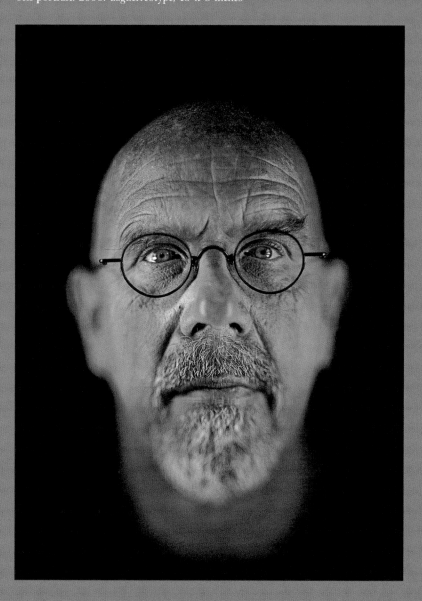

I don't remember exactly where or when I saw my first daguerreo-type. It was probably at the Metropolitan Museum, while I was in graduate school. What attracted me was the combination of poignancy and elusiveness, which also required the active partici-pation of the viewer. The daguerreotype has astonishing detail and a dimensionality, like a hologram. It is not static, because you have to shift the plate to see the image. You have to get close to it to see it, and it flips from positive to negative, so people have to find their viewing distance. We are used to reading photographs as icons; we confuse image with experience, but that gives you nothing of the texture of the thing. When you read a novel, it is not just the narrative line that holds your interest. It is also the syntax, the way the words smash together. So when you look at a daguerreotype, your experience does not stop with the imagery but also involves the physicality of the process, its pictorial syn-tax. A dialogue develops with the object.

The other aspect of the daguerreotype that I find interesting is the intimacy of it. There is so much to involve yourself with that you are rooted in a more careful examination. The daguerreotype is profoundly black and white, and yet it has the ability to make you fill in the image, and that filling in makes the image almost alive. My work is all about the relation of parts to the whole—about focus—and with the daguerreotype, the closer you get, the more you see. It is the opposite with a painting. When you move toward a painting, you reach a point where the image breaks down, and you have to move back to get a sense of the whole. Looking at a daguerreotype is more like reading a book—something you do in private. You have to get into it. You cannot look over someone else's shoulder. And that is perfect for the nudes I am doing now. Looking at art, which most people do

in museums, has become a very public behavior. You are aware of other people looking at you looking at the art, or of you looking at other people looking at art. I want to recover the intimacy, to get away from the social situation of art. My daguerreotypes are in-your-face intimacy, with more than you want to know. It is just you and the body in the picture.

It is so easy for the daguerreotype to be something people gasp over. I do not want that romanticism. I want it to be about our time, to serve my purpose, to be a vessel into which I can pour myself. I respond and learn. It is not a historical investigation, even though I am aware of the conventions and traditions. There is a constant opening up of possibilities, which has always been the key to my art—finding ways to keep myself engaged. When I began to paint, at the tail end of the Abstract Expressionist era, I could see that I did not want to be one more Abstract Expressionist repeating the work others had done better. When I was introduced to Willem De Kooning, I said it was nice to meet someone who had painted even more De Koonings than I had. The point for me was to find a place that was mine, to do something that did not carry a lot of historical baggage. The emphasis at the time, in the late 1960s, was on finding an unused material or a way to work. Everyone could back themselves into their own personal corner and figure out a way to get out. It was about rigorous self-imposed limitations that made it possible to go someplace other people weren't flocking to. My solution was to figure out a process, create a problem to solve, then sign on and ship out and see where the process took me. All kinds of things occur if you are willing to go with a process. New levels of nuance emerge. This is where style is rooted; how you engage a process is often more personal than what you choose as subject matter.

I was struck by a Clement Greenberg quote that really had urgency for me, in effect saying that the one thing you cannot do anymore is to paint portraits. It was like a gauntlet being thrown down. I said, "If this is the one thing you can't do, I'm going to find a way to do it." The interest in process enabled me to make a representational painting in a very minimal kind of way, to get all that virtuoso brushwork out of the picture. From Frank Stella and Jackson Pollock, I took an alloverness, a lack of hierarchy. Portraits historically are very hierarchical. You read certain areas of the face as more important than others. I wanted to make a painting in which no area was more important than any other area and each area had the greatest possible amount of information. I wanted to make something that was impersonal and personal, arm's length and intimate. It would be expressive without any of the usual marks of expression. We have come to equate extremes with expressiveness, but I look for the neutral, the flat-footed, where there is room for interpretation. Using the Polaroid photograph was a way out; and it kept the time frame of the work in the moment, even though it took me a long time to build up a painted image. Paintings exist in novelistic time, and photographs, because they are instantaneous, exist more in poetic time. You don't build a photograph. It just happens. It is all over, all at once, but a painting is unfinished until it is finished.

The daguerreotype gives that alloverness, with maximum information, and it allows me to sneak up on an image. Like all the archaic photograph processes—and like a Polaroid—the daguerreotype delivers instant gratification. You develop it on the spot, you look at it, and you move on, so there is a dialogue between what you just did and what you are doing next.

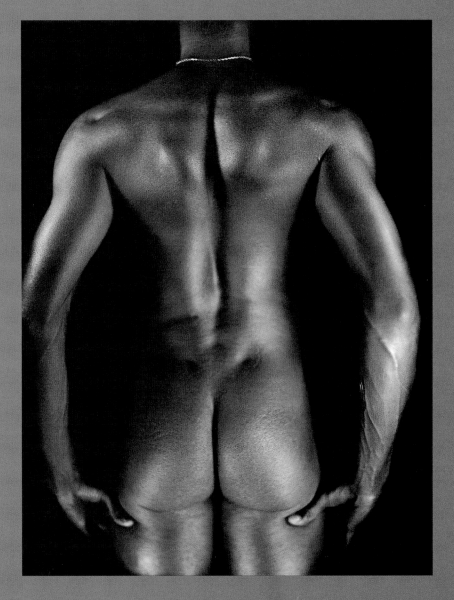

My first experience making daguerreotypes was frustrating. In 1997, Colin Westerbaeck, at the Art Institute of Chicago, who knew how much I like knotty technical problems, used a grant from the Lannan Foundation to set up a project with Grant Romer, at George Eastman House. Grant knew how to make daguerreotypes, which I cannot physically do, and in any case I am more interested in what might be done than in the process for its own sake. We produced small self-portraits. Grant had to set up a makeshift studio here in New York, and the conditions were not ideal. The results were really interesting, but the process was so unpredictable that it just did not seem worth the effort. But there was still some money left over from the grant, and two years later I tried again with Jerry Spagnoli, who had figured out a way to reduce the uncertainty. He has opened doors and made it possible for me to take the process where I want it to go.

I am used to collaborating in my work. In Japan, where I made ukiyo-e woodblock prints, I worked with the woodblock artist, the cutter, and the printer. In a collaboration, there is a tug of war, almost a wresting of control, and you have to make sure your idea and vision are represented. With the daguerreotypes, for example, we started out using natural light with long exposures, but people breathe, their chests heave, which meant that the images came out slightly blurred, and that was not what I wanted. So we worked out a way to use strobes and make the exposure instantaneous. It is important to be able to work this way, not to be under someone else's thumb, to learn on the job, again without a lot of historical baggage about how things ought to be or what they are for.

What have daguerreotypes been best for? People, from minute one. Portraits. My idea was to do the mug shot, as I do with my

Polaroid photography, but instead to do a mug shot of the body. The body is a road map that shows the progress of a life as clearly as any human face; it is as individual as the face, although we do not think of it that way. By deliberately not showing the heads and faces, I give the private information about the person and ask people to see the uniqueness of our bodies. You can see time passing and gravity at work—pre-gravity and post-gravity. I think the wrinkles are beautiful, and even though I am a formalist, I recognize there is a powerful sexual aspect to these bodies. They are sexy. There is a prurience to these images. In some sense, the subjects are reduced to their sexual identity, like the Venus of Willendorf. It probably has to do with my turning sixty, but this is my celebration of the body and also a way to celebrate our common humanity. I think many people are comfortable with acknowledging they do not fit the conventional standards of beauty, and there is an urgency of coming to grips with what has happened to them, to be able to say, "This is who I am now." I have never been a humanist. If anything, I have always erred on the side of remoteness. It is part of my nature. I have always felt that if I just presented what I wanted to present that there was an incredible intimacy to it, that it would be involving. I would tap our shared interest in faces and bodies. That is my kind of humanism.

gustavo frittegotto

1 **series huellas**. 2000. daguerreotype, 24 ½ x 24 ½ inches

40/41    2 **retrato intervenido**. 2000. daguerreotype, 24 ½ x 24 ½ inches

DARIO ALBORNOZ
calle san martin. 2000. daguerreotype, 24 ½ x 24 ½ inches

1

mаrк кеsseLL

1 **unauthorized presence** II. 2000. two daguerreotypes, 5 x 4 inches each

2 **grid** I. 2001. nine daguerreotypes, 5 x 4 inches each

2

1

aᴅam ꜰᴜss

1 **untitled**. From the **my ghost** series. 2000. daguerreotype, 11 x 14 inches

2 **untitled**. From the **my ghost** series. 2000. daguerreotype, 11 x 14 inches

Who loved you more rapturously than I?
May God protect you. God protect you. O God protect you.
The gardens wait, the gardens wait, wait in the nights
and you in the gardens, you in the gardens are waiting too.

I would like to, I would like to instill my sadness
into you, instill it so as not to alarm
your sight of the night grass, your site of its stream,
so that sadness, so that grass would become our bed.

To pierce into the night, to pierce into the garden, to pierce into you,
to lift eyes, to lift eyes to compare the night in the garden
with the heavens, and the garden in the night, and the garden
which is full of your night voices.

I go towards them. Face full of eyes.
The gardens are waiting for you to wait in them.

2

1

JERRY SPAGNOLI

1 **untitled**. september 11, 2001. daguerreotype, 4 ¼ x 5 ½ inches

2 **untitled**. from **the last great daguerrean survey of the twentieth century**. may 2000. half-plate daguerreotype, 4 ¼ x 5 ½ inches

3 **untitled**. from **the last great daguerrean survey of the twentieth century**. july 1999. half-plate daguerreotype, 4 ¼ x 5 ½ inches

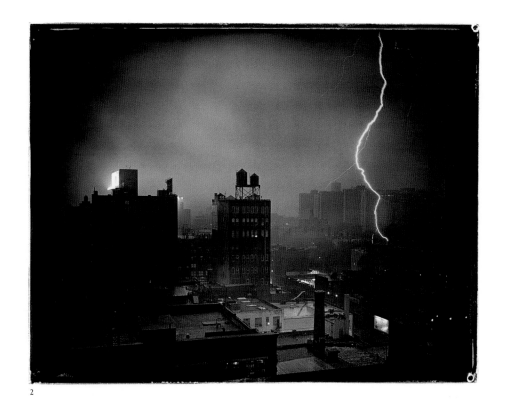

2

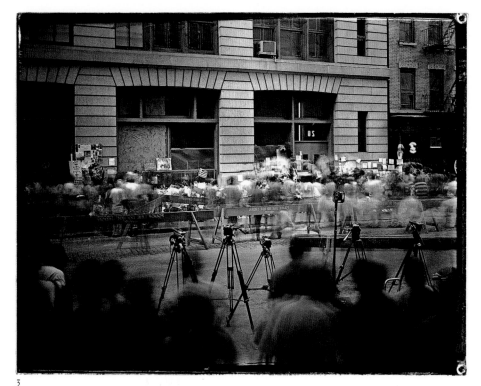

3

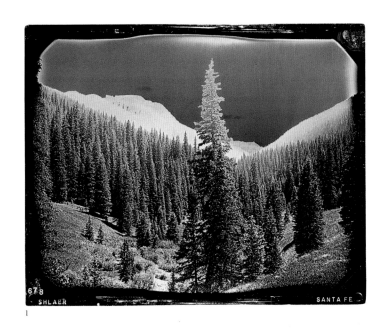

1

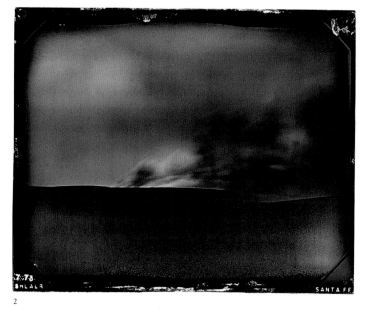

2

ROBERT SHLAER

1 **upper little cimarron valley.** from the **fremont expedition** series. july 19, 1996. daguerreotype, 4 x 5 inches

2 **prairie fire, tallgrass prairie preserve, oklahoma.** from the **fremont expedition** series. september 16, 1997. daguerreotype, 4 x 5 inches

ken nelson
gatineau, ontario. 1980. daguerreotype, 4 x 5 inches

ROGER TAYLOR

For it was universally recognized that here resided the implicit truth of the photograph, locked forever between the fibers of the paper.[37]

Imagine someone encountering a photograph for the first time. Or remember your own experience: the paper rectangle, like a window, directing your attention somewhere else, toward something else. And yet you could not look through it. When you peeked around to the other side, the somewhere disappeared. It was only a paper plane of two dimensions in the real world—a promise, a temptation, a disappointment.

The photograph's truth is thin and flimsy. In Dan Estabrook's studio, a photograph titled *Little Window* is coming into being. Made on paper coated with silver chloride, it shows us only a small square of an image, a window no more than an inch by an inch. It is an homage to one of William Henry Fox Talbot's earliest photographs, of a dormer window, taken on his estate more than 160 years ago. Like Talbot's image, Estabrook's is a negative. It scarcely invites us to look through it because it is little more than a chemical stain on paper, which has, astonishingly, shaped itself into a picture. Before any print has been made, before the positive version enters the world as a full-fledged representation of reality, joining billions of other images, Estabrook has arrested the process, retrieved a record of an image's strange journey into photographic life, revealed the constituent steps, and disclosed unsuspected opportunities for beauty.

At first there was no concept of the positive and negative image. The daguerreotype was a positive, a one-step image on silver plate, a direct transcription of reality, and misleading for that very reason. But the chemists, botanists, doctors, painters, inventors, and clerics who made "sun pictures" on paper saw that light turned silver salts black, so a second step, a reversal, using the first image as a template for exposing a second, was necessary to produce a picture in which the lights of the real world appeared

light and the darks dark. To work with paper photography was not to transcribe reality but to reconstruct it.

Talbot's friend and advisor, Sir John Herschel, coined the binary terms "negative" and "positive" to represent the two parts of the photographic process. Early photographers were fixated on the negative, the process Talbot called, the "original picture," and the "first transfer."[38] Photographers saw the negative as the primary deposit of visual information, and tried to make it as sensitive as possible, in order to recover the world with a minimum loss of information. They experimented with papers of all kinds, from onionskin to fine writing bond to watercolor paper and chemical combinations of silver that produced a dazzling array of colors. In Talbot's investigations, the shades of reality range from brown and orange to blue, violet, and green. There was no black-and-white world. Early photographers brushed on silver emulsion or bathed the paper in chemicals. They struggled with formulas to keep their negatives from fading and altered them at will, waxing them for durability and precision, coloring them for highlights, and penciling or inking in areas to achieve stronger contrast in the positive print. The negative was not sacrosanct; it was a canvas. Talbot proprietarily dubbed the paper negative process a Talbotype, but others called it a calotype, from the Greek *kalos,* meaning beautiful. Prints made from early calotype negatives look more like drawings, watercolors, or Dutch prints than photographs.

Of course, the negative was a means to an end, the production of multiple faithful copies. Louis Désiré Blanquart-Evrard's firm produced more than one hundred thousand prints in the 1840s, Talbot's Reading printer made ten thousand prints in only two months in 1844. The industrial pressure toward precision and conventional legibility was overwhelming. Yet the experimentation

and the variations also became ends in themselves, and paper negatives were often exhibited on their own as valid works of art. Talbot's friends and correspondents were mesmerized by the strange conjunction of abstract beauty and mimetic fidelity. To see calotypes today, at a time when most people have never looked at negatives and digital technology makes them superfluous, is to experience double vision. It becomes difficult to tell which version, positive or negative, holds greater "truth."

The use of paper for negatives lasted scarcely two decades, until the advent of negatives on glass plate coated with an emulsion of collodion. Glass-plate negatives were sharp, stable, and durable. They helped banish the murkiness and imprecision of paper photography and sever its link to drawing. So too did coating the printing paper with a solution of egg whites to prevent the silver from soaking into the paper and blurring the image. Yet in its brief life, the calotype revealed the fundamentally ambiguous nature of photography, mechanical and expressive, ready-made and intentional. The paper photograph itself stood revealed as a series of steps linked to subject and intention, each one an opportunity for manipulation and aesthetic choice. If photography had been limited to the daguerreotype, bound by its tyranny of facts, its unmanageable wealth of detail, the discourse of photographic art never would have progressed beyond the idea of accuracy. Instead, paper gave photography the language and license of art.

When contemporary artists look at old photographs, they tend to see the continuum of interventions. Dan Estabrook's calotypes are essays in the fragility of images, referring to photography not only as a dubious parlor trick, but also as a construction of vision and as a dream based in the desire for something that no longer exists or is not present. So Estabrook's negatives are nearly negligible, almost too thin to be translated into a positive image, certainly not in quantity. He further emphasizes the fragility by printing the positive as a salted paper print, a sensitized piece of paper printed in contact with the negative in direct light until the image gradually appears. The gap between the two reveals the temporal range covered by the production of an image. The positive-negative pair records the transition—the transformation, really—of an instant into an object. In the transition, a different temporal principle takes over, subverting the eternity of the capture and subjecting the image to loss, accident, change, and decay. In Estabrook's world, an image cannot be said to have acquired an artistic life until it has fallen physically into time—and begun to depart from the photographer's original intention to freeze time.

The calotype also solicits Jonathan Kline to contemplate the primary photographic event, the action of light on paper, and his subjects are rigorously chosen to reflect this elemental description of reality. Dust, water, smoke, and strands of hair scarcely qualify as subjects, yet they are for him the quintessential matter of photography because they embody what is transient, accidental, and ignored. The camera alone makes them visible. Through the process of magnification, the camera elevates them into visual objects in their own right and adds them to a lexicon of symbols for the world governed by time and change. These pictures do not "fix" that world but reenact it, postpone it. In the end the calotype and the paper print are just as transient as what they depict. Made of vegetable matter, their fate, too, is organic.

Because of the rage for the daguerreotype, early paper photography was ignored by those in the French government and scientific establishment, who seemed to regard the process as other than

true photography. Today, it is precisely the photographic/not photographic quality of the calotype that has inspired French photographers to resurrect it. The most influential old-process artist in France, Martin Becka, has worked with many alternative approaches to photography. What appears to link his diverse output is the intention to upset all preconceptions about what a photograph is. His calotype-based image of a high-rise development, for example, resembles a Bauhaus-style rendering of a proposed cityscape. The effect transforms the relentless geometries of Modernist-derived architecture into utopian nostalgia, as if the future represented by La Defense had already come and gone, like the city of Jean-Luc Godard's futurist detective film *Alphaville*.

Looking into the fragile heart of paper photography leads to homage and revision. Laurent Millet's photographs, made with a pinhole camera from huge paper negatives and toned with tea and wood stain, side ardently with the Impressionist strain of calotypy. The seaside landscapes of his series *Petites Machines Littorales,* taken in the French Pyréneés, appear as remote as the Amazon and as dreamy as a landscape painted by Corot. Their central subjects are Millet's own stick and twine constructions, based on fish traps made by local fishermen. The photographs appear also to embrace late nineteenth-century anthropology, then an emerging science dependent on the camera for its inventory of topographies, dwellings, structures, customs, and rituals. The natives have vanished from Millet's landscape, however, leaving traces of their handiwork, delicately primitive, which it is the camera's duty to record. Yet the camera cannot discover their origin or use; nor can it disclose whether its record is to be taken at face value.

Nowhere is ambivalence about the nature and purpose of photographic process greater than with the technique of gum bichromate. This elaborate process for making a positive image, perfected in the 1880s by Robert Demachy, has always set itself deliberately against the idea of photographic transparency. In recent times, it has drawn artists into photography from print making and painting. It involves printing the photograph on paper sensitized with a mix of gum arabic, bichromate, and pigment. The gum causes the bichromate to harden depending on the amount of exposure to light. What does not harden can be washed off. The same print can be recoated, reexposed and selectively washed multiple times, with different colors, creating the depth and tone of a painting. In the hands of Edward Steichen and other Photo-Secession artists, the gum print gave photography a complex texture, albeit a borrowed one. The elaborate effects Steichen achieved by combining gum with other processes such as printing in platinum instead of silver have never been duplicated and are still not completely understood. Gum bichromate printing often stretched the connection between the image and its referent nearly to the breaking point.

The most dedicated gum printers today find it impossible to escape the orbit of the Photo-Secession. For many of them, symbolism is the only mode that makes sense with a medium that works against the modern photograph's vocabulary of the captured instant and the sharp edge of fact. In the work of Sarah Van Keuren, for example, the photograph is not a document but a metaphor, connecting inner states with outer reality. Seeing is feeling. The toned, visual effects of gum are a sign that the world is a pretext for the expression of emotion and intuition.

The gum print is a sensual medium with a conceptual edge. Its anti-Modernist photographic texture attracts artists who seek ways to critique the cultural construction of imagery and aes-

thetic experience. In the 1960s, Betty Hahn used gum printing to explore how a printing process might transmogrify the hackneyed icons of popular culture and the anonymous images of the snapshot into something at once more ambiguous, political, and personal. She seized the gum print from the Photo-Secession and gave it to Post-Modernists. Hahn's spiritual heir is surely Kay Kenny, a painter turned photographer, who uses gum printing to compose narratives based on images appropriated from well-known films. In the series *Mirrors of the Moment, Casting Shadows,* scenes from Orson Welles's *The Lady from Shanghai* serve as a storyboard for another narrative of images, a psychic one. The use of gum printing in this case serves to point up the constructedness of the film image, which, in its texture, resembles the fantasy life of erotic longing and fear.

More than anything, gum printing underscores a reality of photographic practice that the Modernist aesthetic sought to obscure—that every step of photography, not just the selection of a subject and the framing of the composition, is mediated by intention. The photograph's relation to a prior reality is always a matter of degree, never a given. Whether the photograph is by Edward Steichen or Robert Capa, the world in the frame is only the expression of an intention, nothing more. Once the world is framed, it is utterly appropriated; it loses its priority. Sherrie Levine makes the point baldly by re-photographing classic photographs; Jonathan Bailey makes it subtly but just as thoroughly.

When Bailey develops the images he takes with his plastic Diana camera, he tones the prints with various combinations of gold and selenium. This now standard practice was begun in the nineteenth century as a way of increasing the longevity and stability of images. Many traditional contemporary photographers—

Emmet Gowin is a good example—manipulate toners for aesthetic effect without ever showing their hand. Bailey pushes his toning until it "splits," until the change from one tone to another becomes visible and sometimes dramatic. His images retain their conventional hold on the scene, but toning can suffuse them with an immanent light or cloak them in brass. In his best work, the toning effectively brings the image together, establishing symbolic relations that the composition itself only suggests. Ends cannot be separated from means.

So the paper photograph is not a "little window" at all, as William Henry Fox Talbot understood, or rather it is a window of a very unusual kind, one that brings into being the very world it purports to describe. It transforms paper, chemicals, and light into a dense, complicated object. And in a final reversal, it makes the object seem to disappear before our eyes, leaving us with the illusion that we can actually see — and that what we see is true.

**WARREN NEIDICH** (WITH ZOE ZIMMERMAN)

**pseudoevent**. from the **american history reinvented** series. 1986. albumen print, 8 x 10 inches

**martial verdier**

**les ambassadeurs.** 1994. silver gelatin print from le gray's waxed paper negative, 48 x 40 inches

1

2

SARAH VAN KEUREN

1 **sun through frost**. 1996. gum bichromate with pinhole camera, 8 x 10 inches

2 **child by lake**. 1993. gum bichromate with pinhole camera, 8 x 10 inches

J. SHIMON AND J. LINDEMANN
debbra at home revealing tiger tattoo, sturgeon bay, wisconsin. 1999. gum bichromate over platinum palladium, 12 x 20 inches

ERNESTINE RUBEN

58/59   **ulricke leaning to left**. 1998. gum bichromate and platinum print, 19 x 24 inches

jon kline
**negative dust** I. 1996. calotype negative, 10 x 8 inches

LUCAS WERTH

**quran school**. 1999. casein print, 8 x 10 inches

MARTIN BECKA
**untitled.** from the **no man's** . . . series. 1996. palladium contact print from le gray's waxed paper negative, 15 ¾ x 19 ¾ inches

magdolna vékás

**details 1**. 1998. cyanotype, albumen, chromotype, salted paper, 13 9/10 x 21 inches

gábor kerekes

**shell.** 2000. carbon dichromate, 3 ½ x 8 ¼ inches

1

DAN ESTABROOK

1 **first photograph**. 1999. calotype negative with graphite, 5 x 4 inches

2 **interior (floating cloth)**. 1996. albumen print, 8 x 10 inches

2

Laurent Millet

66/67     **petite machine littorale du 8.10.97.** 1997. two toned silver prints from paper negatives, 24 x 20 inches each

1      2

Jonathan Bailey
1 **cabo san lucas (baja).** 1981. gelatin silver print, gold split toning with diana camera, 6 x 6 inches
2 **oaxaca, mexico.** 1999. gelatin silver print, gold split toning with diana camera, 6 x 6 inches

*She flirted with her butcher, a handsome but indifferent man*
*presumably tied to the tendon and gristle of his trade.*

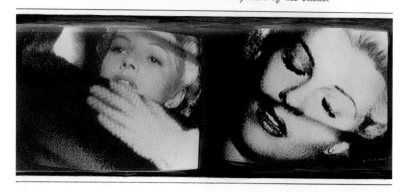

kay keNNy

68/69   **mirrors of the moment, casting shadows.** 1996. gum bichromate, salted paper print, 26 x 20 inches

Judy Seigel
**kinky tramps.** 2001. gum bichromate, 17 ¼ x 23 ¼ inches

aLain ɢiLᴏuin

**untitled**. from the **symbols** series. 1998. gum bichromate, 6 ¼ x 8 ⅕ inches

CHRISTOPHER JAMES
**painters/rangoon.** 1983. ziatype, 5 ½ x 5 ½ inches

LEONARDO FIORAVANTI,
*Il tesoro della vita humana* (1570)

When he turned from the secrets of nature to write a play, he could not leave off hunting miracles.[39]

They hunted miracles, the alchemists and occult masters of the late Middle Ages, and they hunted methodically. The books they wrote as repositories of secret wisdom were anything but airy speculation. They were how-to books for the transformation of the physical world and the acquisition of power—the power to separate out the spirits of metals, the power to banish illness from the eyes, the power to make vermilion in unlimited quantities for the painter's brush, the power to work marvels.

The artists who make wet-plate photographs are the heirs of the alchemical investigators Fioravanti, Albertus Magnus, and Paracelsus. And if they seem jealous guardians of their secrets, it may only be because their art is as much a matter of physical proficiency as of technical knowledge, of things felt as much as seen, of knowledge that cannot be written down. Mark and France Scully Osterman are the foremost practitioners of wet-plate or collodion photography. In essence, they make their own film, as it was made a century and a half ago. They coat glass plates with an alcohol and ether-based solution known as collodion, sensitize them with silver salts, and expose them directly in the camera. The plates are then developed on the spot. All this must be done quickly, while the plate is still wet. The resulting images on glass are fixed with cyanide or hypo. Depending on the exposure and processing, they can emerge either as one-of-a-kind positives—called ambrotypes—or as straight negatives, from which prints of any size can be produced.

Controversy swirled around the invention of wet-plate photography as it did around the medieval "professors of secrets." Englishman Frederick Scott Archer announced the process in 1851 but did not patent the technique. His ownership of the invention was challenged by two other alchemists, the photographic pioneers William Henry Fox Talbot and Gustave Le Gray. Was this like fighting over the bones of a mythical hippogriff? After all, collo-dion is a temperamental process, requiring swift, sure, economical motions in the studio, somewhat between a tennis player's and a short-order cook's. You hold the plate with one hand and pour the chilly collodion with the other. Shooting outside the studio means transporting an entire darkroom. The Ostermans have made collodion expeditions to Ireland, Spain, and Japan with a folding darkroom that they ship through with their luggage. Sally Mann's husband specially outfitted a small pickup truck for her collodion work in the field. On top of it all, sunlight is a questionable ally. Collodion's sensitivity to blue wavelengths means that skies tend to white out with a normal exposure on a bright day.

Yet photographers become initiates into the dark art because it enables them, visually speaking, to turn lead into gold. Collodion creates a substrate for the exposed silver that produces a nearly grainless image. The fact that it also rests on glass and not on absorbent paper increases the precision of the negative. The image retains its astonishing clarity even when enlarged to many times the original size. When it was introduced, wet-plate photography crowded out less precise paper negatives and more expensive daguerreotypes within a few years. And because glass is more durable than paper, the collodion negative opened the door to the mass reproduction of images.

There are other compelling peculiarities to collodion. Because the plate is hand-poured, its surface is never uniform, and even the steadiest hand can leave a pour pattern in the background of the image, a kind of fingerprint. It is possible to look at an old image and tell which corner the photographer held while pouring the plate and whether he (or she) was left- or right-handed. Collodion also encourages a different way of looking at photographs. Compositionally speaking, we read black-and-white photographs as suites of tonal values, which reinforce or play off the iconographic

signs of the image. With collodion, the photographer doesn't compose with tones so much as with perception itself. The collodion renders background and foreground with nearly equal clarity, forcing the viewer into an all-over engagement with the image and overturning visual hierarchies. France Scully Osterman's view of an Irish altar stone exploits all these effects to evoke what theologian Rudolf Otto has called the *mysterium tremendum* of religious experience. Even though the stone actually sits in the distance, it has the presence of an apparition, with light seeming to pour down on it from above. If the same image were taken with a modern large-format camera and conventional film, the effect would be very different, more "natural," even ordinary.

As Sally Mann has remarked, collodion on glass does not allow for drive-by shootings or the profligate bracketing of exposures most contemporary photographers depend on. When Carleton Watkins or Timothy O'Sullivan went into the field with one hundred glass plates, they brought back one hundred images. If a negative didn't work, they could see it on the spot and wipe the plate clean for another try. Collodion images have a constructed, "graven" quality, as Mann has said. This is especially so with the ambrotype. To be visible as a positive, the collodionized plate is underexposed and the image is either made on a dark-tinted glass or clear glass backed with a dark color. Unlike modern films, the highlights are bright deposits of silver. Shadows come from dark places under the image. To turn a purple-hued ruby ambrotype in your hand, to see that the image so complete and deep is nothing more than frost on the glass, is an eerie experience, like seeing a thought materialize.

As with any occult practice, the ambrotype has attracted a variegated crowd of adepts. They include not only the Ostermans and Mann but also militant traditionalists such as John Coffer, who has spent much of his career making ambrotype portraits in the nineteenth-century manner. Luis Gonzalez Palma, like Mann a photographer known for gelatin silver-based images, has collaborated with several collodion artists, including Paul Taylor of Renaissance Press, to perfect the hypnotic qualities of ambrotype portraiture. His meticulous and hyperreal images suggest that the ambrotype's attraction as a keepsake resides in its capacity not merely to stir recollection but to give the impression of physically recovering a lost person. The ambrotype is named for the Greek word *ambrotos* meaning immortal or imperishable. Ambrotypists populated Civil War encampments, making what, for many of the customers, would turn out to be their last pictures. Imagine receiving such a likeness in the mail along with a notice of death on the battlefield. "I would rather have such a memorial of one I dearly loved than the noblest artist's work ever produced," wrote Elizabeth Barrett Browning.[40]

The spirit of collodion portraiture is a flirtation with the spirit world. For Jody Ake, ambrotype self-portraits promised to reveal things about character and fate he could not discover by looking in a mirror. In 1990, he was in an automobile accident that broke his spine in two places and put him in a body cast for seven months. He emerged with the guilt of survival and a detestation of perfectly made images. He began to scratch his negatives and burn them with cigarettes. Then he saw an ambrotype whose image was flaking off and realized he had found a medium to express his sense of damage and disappearance. His large-format self-portraits, made on thick, heavy pieces of glass, project a kind of alter ego, occupying an ominous territory of violence and decay. "I turn the camera on myself as a form of soul searching," he has remarked, "for signs or messages. I never know what I'll see when the image pops up."[41]

It is the nature of photography to frame, authorize, and transform into customary appearance everything it renders, even the

most shocking or preposterous anomalies. Stephen Berkman, who has learned collodion techniques from both Coffer and the Ostermans, finds in the ambrotype an opportunity for theatrical fabrication, with history itself as a collaborator. Berkman uses collodion to anchor implausibility and give unreality a historical patina. He stages elaborate tableaux with nineteenth-century characters performing for some obscure purpose, like the more bizarre motion studies of Eadweard Muybridge. In one sequence, the performance artist Laura McMurray, dressed in a costume made of sticks and looking like a Kwakiutl shaman, gestures over a small cage. Berkman shot several ambrotypes of the gesture, then combined them in sequence, in effect creating a collodion motion picture, perhaps the first since Henry Heyl's "phasmatrope" of 1870.

In Werner Herzog's film *Heart of Glass,* the protagonist searches obsessively for the formula for ruby-colored glass. Beyond collodion itself, it is the glass plate as the foundation of an image that renders this early form of photography Promethean, hermetic. The glass of the lens transmits light, and the glass of the plate records its passing. Whatever falls between the two is all we can know of the visible universe. Glass is a metaphor for vision, imagination, and self-reflection. We can imagine that the ancient sun-worshiping Zoroastrians might have made photography their ritual art. In such a case, Hungary's Gábor Kerekes would have been their Zarathustra.

In the 1970s and 1980s, Kerekes was Hungary's premier photojournalist. He developed a brooding, dispassionate style that enabled him to convey a guarded pessimism that was difficult for the Communists to censor and impossible to conscript into any campaign for a brighter future. In the 1980s, however, he stopped working. "I had grown tired of making images ordered by someone else," he remarked. He destroyed all but thirty-five or so of his images and turned inward. "I couldn't see in the real world what I sought emotionally and spiritually," he added.

For eight years, Kerekes immersed himself in the study of philosophy, natural history, and alchemy. He emerged with a repertoire of disturbing visions and an intense interest in old photographic techniques. His pictures, often salt or albumen prints made from glass negatives coated with silver gelatin emulsion, are richly toned dreams, some nightmarish, some visionary: a truncated elephant's foot, a shell collection (referring to Daguerre's early imagery), a streaking, apocalyptic comet. As he has always been, Kerekes is again a herald; his work has inspired a growing old-process movement in Hungary, a country rich in fine-art photographers.

Up until the 1930s, Hungary was the most photographically active country in the world. World War II and Communist rule ended that. Now, after the rebirth of democratic rule, many of the same artists who had worked clandestinely under Communism are implicitly protesting what photographer Sándor Szilágyi has called the "depersonification of photography" in a money-based economy.[42] Capitalism has brought the freedom to revive Hungary's great photographic tradition but, in Szilagyi's opinion, it has also distanced by several steps the interactions between people and between artists and their media, especially photographic artists. For him, digital imaging is the ultimate symbol of this depersonification, a process in which the immaterial and abstract (data) is substituted for the tangible and expressive (the negative, the print), which ideally forms the basis of a human transaction. The photograph is a handmade object that can be directly and physically exchanged between people.

For these photographers, as with all alchemists, vision inheres in a knowledge of materials—glass, paper, light, emulsions. Images on glass are metaphors for a harnessing of the hand's intuition by the mind's eye, a combination powerful enough to transmute the world.

LuIS GONZALeZ PALMA
**ballerina #2.** 1999. ambrotype, 7 x 7 inches

1

france scully osterman

1 **papaya**. 2000. ruby ambrotype print, 10 x 8 inches

2 **the altar stone**. 1996. toned silver gelatin print from collodion glass negative, 13 x 18 inches

2

1

saLLy LaRseN

1 **kyoto pond.** 1987. orotone photograph, gold leafed, on fifteen glass plates, 8 x 10 inches each

2 **vatican double spiral.** 1983. orotone photograph, gold leafed on glass plate, 16 x 20 inches

2

saLLy maNN
**eva series**. three silver gelatin prints
from collodion glass negatives,
10 x 8 inches each

Wet-plate or collodion photography was invented in 1851 by the Englishman Frederick Scott Archer. The technique consists of coating a glass plate with a solution of nitrated cotton dissolved in ether and alcohol. The coated plate is bathed in silver nitrate to make the surface sensitive to light and exposed in the camera while the collodion is still wet. The plate is then developed and fixed. Collodion can produce either a negative on glass or a positive image if underexposed, backed with dark material, and viewed by reflected light. This one-of-a-kind positive image is called an ambrotype. For most working photographers, wet-plate negatives were preferable to paper negatives because of their great clarity and speed. In the 1990s, photographer Sally Mann began to experiment with wet-plate techniques and now uses the process in most of her work. The following interview was conducted in August 2000, in her studio in Lexington, Virginia.

**LYLE REXER:** The first collodion images of yours I saw were at Edwynn Houk Gallery in 1999, the 40-by-50-inch photographs from Mississippi. But years earlier, in the landscapes you made for the series *Motherland*, it seemed to me you were already thinking in terms of collodion. Some of the *Motherland* pictures looked more like Mathew Brady images than real Mathew Bradys.

**SALLY MANN:** Actually, it was the lens I was using that gave me that effect. I was invited by the High Museum of Atlanta in the Olympic year to make a photographic landscape tour of Georgia, and it just seemed natural to approach the project in a way that recalled the nineteenth century and the Civil War. I used Ortho film and my view camera and just let it happen. In some cases the film is overexposed, in other cases it is cracking, as if it were decomposing. To the untrained eye it looks a little like collodion, or at least of that era. I don't remember exactly when I made the step to collodion. I saw a picture of an altar stone done by France Scully Osterman and it arrested me. I tried to make them on my own, but I very quickly realized I needed help, so I invited France and her husband, Mark, to come down to Virginia, where I live, and do a kind of workshop with me. I must have driven them crazy, at first. I could not even spell collodion.

**LR:** So the images from *Deep South* were the first you made with collodion.

**SM:** Actually, the first one was of Larry, my husband, in our swimming pool. But I used collodion with some of the photographs I shot in Mississippi for *Deep South*. I wanted to capture the solitude and resonance of that landscape, of places where time seems stopped, lost, warped. That part of the South is a kind of netherworld. I was asking the land to give up its ghosts. Collodion is the ideal medium for such landscapes. It is contemplative, memorial. Larry built me a portable darkroom for the back of my truck, and I made the trip alone. I slept in the truck. The entire trip seemed blessed with a mixture of astonishment and thanksgiving.

**LR:** For me, collodion is fascinating because of its play between clarity and dreaminess, or clarity and wildness. The swirling pattern of the pour can create a feeling of storm and apocalypse.

SM: The clarity brings you into the picture, into the landscape. That is especially true of the ambrotype, which is a medium I love. But what truly attracted me to the process was its reverential quality. In the face of some extraordinary sight or place, you fashion an object, you do not just take a picture. It is ceremonial. I am not a religious person, but there is an experience of communion in wet-plate photography. It is not a drive-by shooting. When you pour the plate, it goes cold in your hand, and a wonderful frisson goes through you. And when you develop it, it is like primordial magic or alchemy. I still feel that, every time I make a new plate and the image appears. Perhaps because of its sensitivity to certain wavelengths, collodion is also able to capture aspects of light, a refulgence, that conventional silver film cannot.

LR: If you follow the progression of nineteenth-century photography, using collodion today is a bit like drinking a glass of water with your hands tied behind your back. A hundred and forty years ago, all they wanted was to get a consistent image quality. The effects and accidents that entrance us today—the swirl of the background from the pour, the white skies, the flaws and comets—were a nuisance, a limitation, a commercial disaster. What they once endured of necessity, we now employ as art.

SM: I have never been a slave to technique. Many of my noncollodion pictures are all wrong from a conventional point of view. I shoot into the sun. I underexpose and overexpose. When I shoot collodion, I embrace the accidents, the serendipity of the process. I had an intern, once, who was worried about getting the right lens for her work and was going to run out and buy a new one. I told her to go to the thrift shop and buy whatever she could find and see what would happen. Mistakes are not the end of the world, and perfection is not my goal. Proust writes about being visited by "the Angel of Certainty." I solicit visits from the Angel of Uncertainty.

LR: Ambrotypes are a somewhat different story.

SM: I have begun to make them, and they are less forgiving. You have to get the exposure and the developing right or the image will not show up as a positive. But when you succeed, there is nothing like it. It is three-dimensional, and as you look, you seem to enter into the image.

LR: Speaking of three-dimensionality, do you think photography is losing something by going digital? It seems like a natural evolution, from better lenses to faster films to motor drives to digital processing. Most people think the history of photography, if it has a history, is really a history of technology. Wouldn't William Henry Fox Talbot be going digital if he were alive today?

SM: I believe the loss is impossible to calculate. Or rather, digital image making is a different activity altogether. The digital image is like ether, like vapor that never comes to ground. It simply circulates, bodiless. It has no material reality. The entire world of

mechanized photography seems to me fundamentally mistaken as well, just too darned easy. What does a picture mean when you set your motor drive and shoot two thousand frames of the same thing, and the last one you take, when you turn away or cough or drop something, is the one that ends up on the cover of *Artforum*? You are not paying your dues. There is something that happens when you look at a potential picture and know it is going to cost you dearly in time and energy. You have to make decisions. Collodion especially requires this discipline, this thoughtfulness. It forces you out of the time of the thing you are looking at and into the time of the picture itself.

LR: It emphasizes the element of craft.

SM: Craft is too common a word. For me, nineteenth-century photography is simply unsurpassed. There is an elegance to it, a purity, that has nothing to do with naïveté. What compels me about the nineteenth century is that its artists conducted a comprehensive investigation of what the camera could elicit. They wanted to know what the camera had to do with reality. It is not that they wanted to see what the world looked like. They wanted to see what it looked like *photographed*. And that is still the point—curiosity with the hope of revelation. When I come upon a place that has a resonance, I know instantly that I want to make a picture. I am in a fever of excitement, afraid it will all vaporize. Yet it does not look in reality the way it will in the image. I know what I feel, and I just hope the camera can somehow see what I'm feeling. Collodion is especially satisfying because you process it on the spot, and the revelations are nearly instantaneous.

LR: In 1972, you discovered a cache of glass-plate negatives by the Civil War–era photographer Michael Miley, who was from Lexington and is known as Robert E. Lee's photographer because he shot so many images of General Lee when Lee came to Lexington to be president of Washington and Lee University. You printed thousands of those negatives. Was he an inspiration to you to work in collodion? Have his images influenced you?

SM: I sometimes think everyone influences me. I am an inveterate borrower, always internally referencing other pictures. But Miley's work was influential in a broad rather than a particular sense. What I was looking for in his images—I think there were ten or twelve thousand, and not all of them were exciting—were clues to my native land. Larry and I had just moved here for good, and I wanted to find all the places Miley had photographed in and around Lexington, to see how they looked, how they had changed. It's a little bit like Mark Klett's survey project out west. But Miley was frustrating because he was really more interested in cataloguing the people of Lexington, something along the lines of August Sander. All I wanted were more landscapes. I wanted to know where I was.

LR: You have been working on a collodion series based on the death of your greyhound, Eva. You call them "graven images," an evocative description. How did they happen?

SM: They are graven, excavated as opposed to pixilated. Eva was our beloved greyhound, and she died instantly of a heart attack one day while running. I wanted to do something to memorialize her, and I couldn't bring myself to bury her, so we had her skinned and then set her remains out above ground, protected from animals. After a year, the bones made a strange and beautiful study. The decision to photograph them in wet plate just came naturally. There was no other way to do it. I mean, I walked into my studio with a bag of bones and dirt, emptied it on the floor, and started pouring a plate.

LR: The images do seem graven, unearthed, and the scattered bones seem almost like the letters of a language lost to our understanding, left to us to decipher.

SM: To my mind, this series is the perfect marriage of subject and technique. The ragged edges of a collodion image appear to be torn, seized from the flow of time. Ordinary film would be too slick to capture the state of decomposition.

LR: It does seem strange to me to think of you as an old-process photographer. Especially after *Immediate Family* and the ensuing controversy over your portrayal of childhood, with its overtones of sexuality and death, I always associated you with the cutting edge of straight art photography, at the flashpoint for all kinds of cultural, aesthetic, and political issues.

SM: Maybe this is the cutting edge. I never thought of many of the people you write about—Adam Fuss and Chuck Close, for example—as old-process photographers, but they are. There are a legion of us out here. And who knows? In the not-too-distant future, as the world moves toward filmless image making, anyone who picks up an ordinary camera and spends time in a darkroom will be classified as an old-process photographer. We will all be antiquarians.

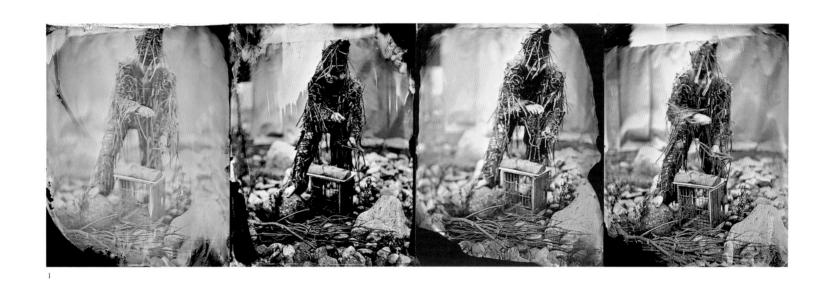

1

STEPHEN BERKMAN

1 **fire maker**. 1999. four ambrotypes, 10 x 8 inches each

2 **untitled**. 2000. sixteen transparent ambrotypes (collodion positives) backed by a mirror, 72 x 56 inches

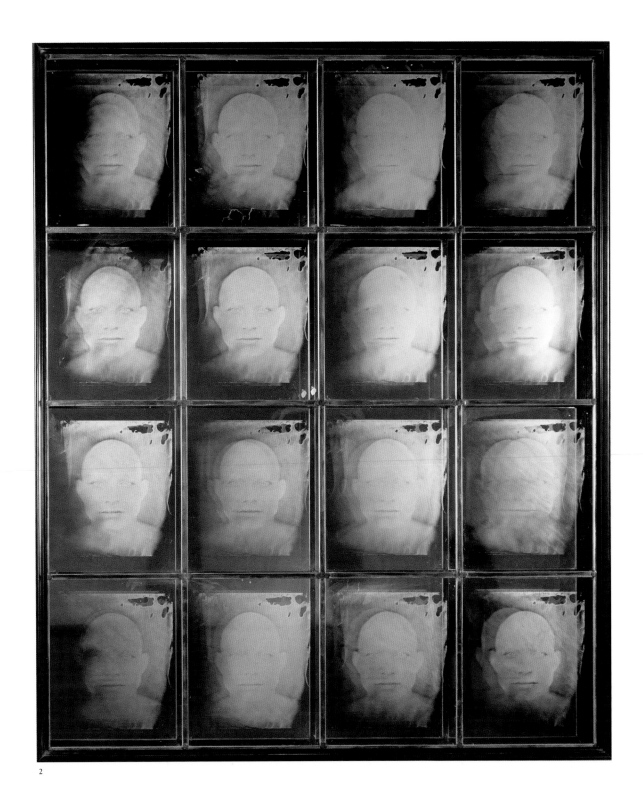

2

1

mark osterman

1 **lathe**. 2000. tinted ambrotype, 10 x 8 inches

2 **three heads**. 1999. tinted ruby ambrotype, 8 x 10 inches

2

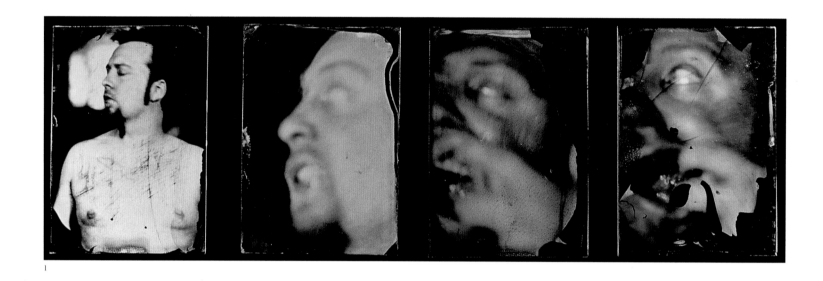

1

JODY ake

1 **self-portrait in four.** 1998. four ambrotypes, 7 x 5 inches each

2 **untitled self-portrait.** 1999. ambrotype, 11 x 12 inches

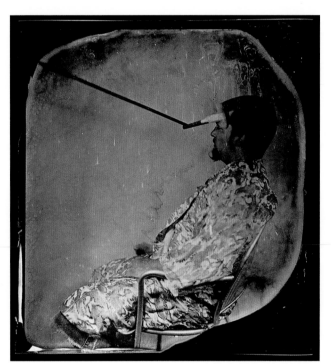

2

1

2

ɢábor kerekes

1 **coma bennett**. 1997. silver print on printing-out paper from a gold-toned glass plate negative, 7 x 7 inches

2 **retort**. 1998. printing-out paper from a glass plate negative, 5 x 4½ inches

jean-jacques salvador

**attirance-répulsion**. 1998. two ambrotypes, 39 x 39 inches each

Tinhorn. Tin Lizzie. Tin whistle. Tin badge. Tin Pan Alley. A tin ear. Cat on a hot tin roof. Not on your tintype. The word *tin* connotes something cheap, shoddy, as opposed to something valuable, something in silver, gold, or even brass or steel. Tin is temporary, disreputable. From its invention in 1853, the tintype was a poor man's keepsake, providing an ersatz version of photography's most personal and aristocratic experience, the daguerreotype. Never mind that it contained no tin at all.

The classic tintype is a one-of-a-kind direct positive image, like a daguerreotype or a glass-plate ambrotype. It is made on a thin piece of iron—a ferrotype—or aluminum, coated with asphalt, then sensitized to light with salted collodion or a gelatin emulsion of silver salts. Slightly underexposed, the image shows up after developing as a positive against its own black background. The tintype could be taken, developed, cased, and sold on the spot, a pre-Polaroid form of instant gratification.

Gone was the silver evanescence, replaced by a dark or milky ambience that was often garishly tinted after the fact. Tintype portraits frequently look like ads for an undertaker's service. Why, then, should they be taken at all? "Well, that depends on the circumstances," wrote R. W. Hubbell in 1884:

> If a man has enough photo work to keep him busy, then tintypes are only a detriment to his work; but if he has not, he will, in most cases, need to make tintypes to fill his purse.
>
> There are oftentimes pictures wanted in a hurry, when photos could not and would not be made. In these cases, a tintype fills the bill to a T.
>
> And then there is a large class of customers who want pictures, but who will not pay the price of a good photo; and as a good gem is much better than a poor photo, I think they should be made.
>
> When a big rural chap comes into your room and prices your cabinets, you tell him six dollars per dozen, and when he tries to [talk] you down to two for a quarter, then it is time to show up your tintypes. Even then he will turn pale when you tell him four for seventy-five cents, and he will commence quoting prices of all the other photographers within a radius of twenty miles. Tintypes are cheap: for all that, there is money in them, and they do very well when kept in their proper place.
>
> At any rate, people will have them, and we may as well make them, and get all we can out of them.[43]

The nineteenth-century tintypist's motive was nakedly economic. The medium's cheapness, however, combined with its physical solidity, perfect as a memento, enabled the tintype to survive well into the twentieth century, albeit often as a sideshow curiosity, and to act as a force for the democratizing of photography's consumption.

For Jayne Hinds Bidaut, the tintype is not demotic but charming in its poignancy, which is the anonymous pathos of the aspiration to defeat time. She sees in the medium an analogy to the insect specimens she collects. Just as they represent to her a vanishing biological diversity, wiped out by modernity, so the tintype, above all other mediums, represents the vanishing diversity of photographic practice. When she set out to master the tintype, however, she also discovered a medium that could harness uncertainty and fashion metaphors for the "metamorphosis of the soul," as she puts it.

Bidaut's specimens of moths, butterflies, and beetles seem to float in a luminous, delicately colored element. They are three-dimensional, like creatures perfectly preserved in amber. For

this work, Bidaut makes a photographic positive and uses it to create a tintype positive on a dry plate of anodized aluminum coated with variants of a commercial silver emulsion. She also creates one-of-a-kind tintypes in camera. In both cases, the image is captured without the intervention of a camera mirror, so it appears reversed—as did antique tintypes.

An emphasis on the sensuality of sight informs Bidaut's nude studies in tintype. She poses draped nudes in the neoclassical style of the Beaux Arts period, which was itself the model for most nineteenth-century French pornographic photographers. In photography, the disreputable could acquire most readily the luster of the fine arts. Bidaut's nudes, which range from locket-sized images made with a gem camera to elaborately framed 24-by-20-inch in-camera portraits to stereograph images (an early version of 3-D), recover a prurience fundamental to photography but lost in the inundation of sexualized commercial imagery in the late twentieth century. Bidaut formats her smaller nude images as keepsakes, using antique cases she collects. One case she found had been opened so often it registered the fingerprints of its owner. Bidaut wondered at an image that could be powerful enough to draw the eyes of a beholder again and again. Perhaps it was not only the image but the medium itself, stimulating fantasy and promising possession.

Bidaut elevates the tintype above its second-class photographic citizenship and, perhaps, beyond photography itself. Her sense of a photograph is as a physical object, not a text, a visual mystery, not a message, a stimulus to imagine, not a summons issued to halt time.

In one way or another, all contemporary tintypists address the medium's class origins. For photographer John Coffer, the tintype initially provided a way to connect himself with an authentic, rural America and to a populist spirit of individual entrepreneurship symbolized by the itinerant photographers of the nineteenth century. For more than twenty years, Coffer has been making tintypes and living a life that mirrors his art. In the 1970s and early 1980s, he crisscrossed the country by horse-drawn wagon in an 11,000-mile odyssey, making and selling tintypes. He is now ensconced on a farm in the Finger Lakes region of New York State, where he lives without electricity or running water; his cabin is his darkroom. Unlike the contemporary photographers David McDermott and Peter McGough, who adopted Edwardian dress and style as an aesthetic gesture, Coffer's choice is political, a conscious rejection of a society based on consumption and dependent on technology. "I happen to think a horse and wagon are more beautiful than a John Deere tractor," he once remarked.[44] His work, if not his example, has inspired and instructed an entire school of contemporary tintypists.

When Coffer started out in the 1970s, most "antique" photography was actually Polaroid prints, tinted or covered with brown cellophane to look old. Only a handful of people were experimenting with tintypes and glass-plate photography, including Tony Kaburis, Hiroo Ishikawa, and Doug Munson, who founded Chicago Albumen Works, now a major supplier of old-process papers. Coffer first worked with modern materials, including aluminum plates commercially enameled (japanned). He sensitized them with a standard photographic emulsion because there was no way to learn the original wet-plate formulas. He once visited the Smithsonian Institution seeking information only to be told, "Let us know when you find out how it's done." He found out. In the early 1980s, with a cache of old man-

uals and a copy of William Crawford's *The Keepers of Light,* Coffer set out to master the wet-collodion tintype and ambrotype. He taught himself how to japan the iron plates, mix the collodion solution, and sensitize the plates. He also creates his own beautifully crafted cases and lockets.

Until the late 1990s, Coffer worked mostly at Civil War re-enactments and historic sites. His last horse-and-wagon trip was to the 1998 Gettysburg re-enactment, where more than 24,000 participants and visitors and a host of wet-plate photographers showed up. He had taught many of them. His re-enactment portraits and reportorial battle images are scrupulously faithful to the details of the past, but he also does what few nineteenth-century tintypists would have bothered to do: He trains his camera on noncommercial subjects, usually simple objects and scenes near his cabin. This is certainly not a practice R. W. Hubbell would have thought very remunerative. The result is images evoking a pastoral innocence but with a contemporary clarity inherited from such artists as Walker Evans and Minor White.

With its populist aura, the tintype is almost inevitably a political form. For Deborah Luster, the collision of class, justice, and art is the substance of her portraits. She is less interested in the process or its aesthetic effects than in its social subtext. She uses the tintype as a standard print medium for a series of portraits of inmates in jails and prisons across the United States. The pictures were all made in collaboration with the subjects, and they evoke at least four distinct levels of suggestion, four roles for photography. The first is the documenting of economic marginalization. Luster's subjects are people who, a hundred years earlier, would have been able to afford only a tintype, if that. At the second level, they are also "desperadoes" in a photographic sense, objects of the camera's voyeurism, just as, say, the conspirators in the Lincoln assassination were after their capture and display. At the third level, Luster's portraits represent a constructed social type, as did August Sander's classifying portraits of Germans in the 1920s. The type in this case might be "criminal." Finally, in contrast to society's construction of their meaning as mere type, they also exhibit the individuality and interiority that modern portraits convey and celebrate. The tintype brought art to a class of people deemed unworthy of it, and there is about Luster's project a Depression-era commitment to assert the worthiness of "those in the shadows you do not see," as playwright Bertolt Brecht put it. As an artistic genre, these tintypes seek to recover an immediacy for the portrait that has been lost to the two-dimensionality of media representations.

For Warren Neidich and Christine Schiavo, the tintype is a spurious document, whose impact has far more to do with fantasy and projection than with a description of reality. Neidich is concerned with the ability of photography to codify historical "reality" while in fact limiting our perception and understanding of history. His projects expose this tendency in a variety of ways, even as they stand on their own as visually compelling objects. For the series *Contra Curtis: Early American Cover-ups,* Neidich made platinum prints of images captured from the television broadcast of the film *Cheyenne Autumn.* The scenes of a savage cavalry attack on an Indian village have the feel of CNN footage but in an art format the photographer Edward S. Curtis might have used.

The tintype suits Neidich's critical intentions because of its use during the period of the Civil War. The physicality of the tintype lends it additional credibility as a document, a credibility on which re-enactment photographers play. John Coffer's re-enactment

tintypes and ambrotypes are almost indistinguishable from vintage plates, and new work by other re-enactment photographers has been offered over the Internet as genuine Civil War memorabilia. Neidich shot a series of aerial photographs of re-enactment encampments, and enlisted John Coffer himself to reproduce them in tintype. We have become so familiar with aerial photographs of battle targets, through coverage of at least four wars, that it takes some time to grasp that these images could not have been made during the mid–nineteenth century, and that either the tintype is fraudulent or we are looking at some modern military engagement, perhaps the Gulf War.

Christine Schiavo began to make tintypes in part to break free of the standardization of the Kodak paper surface. She has used other materials, including birch bark, to wage the same battle. Schiavo's series might be seen as the dark side of Bidaut's aesthetic environmentalism. Schiavo's insects are clearly dead and damaged, as if their carcasses had been dropped onto the plate and photographed. The insects are trash, the detritus of natural processes, and the images appear almost equally disposable, appropriate to a cheap, undignified medium. Dan Estabrook has embodied a similar intuition about the physical inferiority of the tintype. In his series of tintype torso studies, the distressed images appear to be disintegrating, along with the tintype plate itself. A metaphor for the body's fate, the series seems to comment on the vanity of investing any physical object with the desire for immortality or transcendent significance.

Schiavo's floral still lifes use the dark background of the tintype plate to make an additional point about the tenuous nature of photography's connection to the seen world. These still lifes are not merely contrivances, as all still lifes are, manipulating nature to some moral or aesthetic purpose, usually about transience. They are also imaginary and confected. The dim floral images are actually elaborate landscapes, made from multiple film exposures using constructed sets, film projections, and drawings. These landscapes are impossible to place, and any perception of depth is clearly an illusion, albeit a complicated one. The images fail utterly by nineteenth-century standards of beauty, clarity, and truth to nature. They are intended to exist in a different way, as palimpsests rather than as representations of a unified field of vision. They show that beauty as such never resides in the thing imaged but in the image itself, or rather, in our experience of the image, including its constructedness and distance from things seen. Nature is only an occasion. It is supplanted by the assembly of recollections, analogies, and associations that are the true material of art.

1

2

JAYNE HINDS BIDAUT

1 **the knot.** 2000. in-camera tintype, 14 x 11 inches

2 **common egret casmerodius albus.** 2000. tintype, 10 x 8 inches

3 **chrysemys scripta elegans (turtle skeleton).** 1999. four photogram tintypes, 10 x 8 inches each

3

1

CHRISTINE SCHIAVO

1 **palm**. 1998. tintype, 4 x 3 inches

2 **untitled**. 1997. tintype, 5 x 7 inches

3 **daisy boys**. 1999. tintype, 5 x 7 inches

2

3

DAN ESTABROOK

untitled twins (joined). 1993. emulsion on steel, 10 x 15 inches

**WARREN NEIDICH** (WITH JOHN COFFER)
**aerial reconnaissance photographs, battle of chicamauga circa 1863.** from the **american history reinvented** series. 1987. tintype, 10 x 8 inches

1

DEBORAH LUSTER

1 L.S.P. **52, angola, LA, 1999.** from the **one big self: prisoners of louisiana** series. 1999. silver emulsion on two aluminum plates, 5 ½ x 4 inches each

2 L.S.P. **107, angola, LA, 1999. jerome hudson.** from the **one big self: prisoners of louisiana** series. 1999. silver emulsion on aluminum, 5 ½ x 4 inches

2

1

JOHN COFFER

1 **civil war reenactment**. 1999. tintype, 6 ½ x 8 ¼ inches

2 **objects on bench**. 2000. tintype, 7 x 5 inches

2

They said, "You have a blue guitar,
You do not play things as they are."

WALLACE STEVENS,
*The Man with a Blue Guitar* [45]

The man replied, "Things as they are
Are changed upon the blue guitar."

In Julia Margaret Cameron's photograph of 1867, Sir John Herschel, scientist, astronomer, and photographic pioneer, looks as mad as a hatter, as mad as any asylum dweller depicted by the early medical photographer Hugh Diamond. So many of the figures portrayed in nineteenth-century English and Scottish photography have a distracted aspect—Carlyle, Tennyson, many of the Scottish clerics in Hill and Adamson's portraits—the age itself seems disturbed, even demented. In Herschel's case, it is as if a division had rent his very nature, running through him and through photography itself. Herschel gazed at the heavens and into the chemistry of light. He charted the appearance of stars, almost casually discovered the way to "fix" a photographic image, coined the fundamental terms of photography, *positive, negative,* and *snapshot.* He was a dissector, but desultory, a scientist, but abstracted. He was a visionary, an unsystematic philosopher, a photographer with little interest in producing images. And the one photographic method Herschel invented, permanent and precise, could display the universe in detail, but only in shades of blue.

From the outset, the cyanotype severed itself from any neutral relation to observed reality. Apart from the sky, which is never deeply blue, blue is a relatively rare color in nature. So the Romantic German poet Novalis, in the novel *Henry Von Ofterdingen,* chose a blue rose as his mystical symbol of the unattainable. The cyanotype, a method of making photographic prints in which the paper is coated with a solution of iron salts rather than silver, produces a full gradation of tones when exposed to light, from the most intense blue to the palest pastel. To contemporary eyes, conditioned by abstemious black-and-white and the baroque saturations of Fujicolor, the cyanotype's overwhelming impression is cloying. Yet we are not the first to be repelled. The conditioning of vision and the banishing of blue began

early. Of the photographic pioneers, only Henri Le Secq and, to a lesser extent, Edward S. Curtis printed in blue. By 1890, most photographers used cyanotype only for proofing negatives, like a contact sheet. P. H. Emerson declared the blue an abomination: "No one but a vandal would print a landscape…in cyanotype." [46]

But why shouldn't the photographed world be blue? A blue photograph is no more artificial than black-and-white—or pale brown, purple, orange, or rose, some of the colors that light can produce on paper coated with silver salts. The cyanotype galls purists because it cannot be neutral and resists naturalization by the eye and mind. It advertises the gap between things seen and things seen photographed.

Unreal blue was itself divided in its applications, and the division persists in the revival of cyanotype. Cyanotype's precision and its simplicity of development—only two chemicals to mix and only tap water and sunlight required for development—made it easy, cheap, and industrially attractive. The first true book of photographs, Anna Atkins's *British Algae: Cyanotype Impressions* (begun in 1843), was a botanical catalogue made by placing the specimens of dried seaweed on coated sheets of paper and exposing the paper to light, leaving a reverse silhouette impression. Her utilitarian intentions of speed and accuracy subsumed her attraction to the beauty of the process, but the aesthetic allure was real and strong.

Henry Bosse felt the same. An engineer with the U.S. Corps of Engineers, the former stationer and German immigrant conducted what was perhaps the first photo-mapping project in history, a survey of the Mississippi River between Minneapolis and St. Louis. The complete set of views, made between 1883 and 1891, captures the lay of the land along the developing waterway, from rural riverbank to railyard, with special attention to the intricacy of bridges. Yet this is no mere blueprint of American expansion. Its cumulative effect is

poetic. Like the woodblock prints of Hokusai, produced in Prussian blue ink and collected at the time by connoisseurs from Paris to Chicago, Bosse's views were framed (in ovals) and gathered in albums as aesthetic testaments. "To reflect on water and light, he used blue and white…and time," writes Charles Wehrenberg.[47] The utilitarian medium was also a pictorial means to forge a connection between inner states and outer realities.

The cyanotype remains available to artists precisely because it embodies this contradiction between information and expression, between the documentary and the metaphoric, unpretentious industry and unadulterated art, that lies at the heart of photography. The contradiction attracted Robert Rauschenberg like a magnet. When he made full-body cyanotype photograms of his wife and friends in the 1950s, he acted with the same intention as a common blueprint-shop technician catering to the architectural trade. Here was a quick and dirty way to make images for sale, to force the door of the art world without taking the time to fabricate elaborate paintings nobody was willing to buy. The industrial process, long since purged of the painterly pictorialism of photographers such as Paul Haviland and F. Holland Day, was art nevertheless, and nothing but, for it provided a vehicle for Rauschenberg's anti-Expressionist strategy. He denied explicitly an emotive language for art that attributed feelings or expressive meanings to color. Blue was blue, a strictly adventitious color.

Other artists with slightly different axes to grind turned to blue. Cyanotype was not only easy to do, it could also be applied to almost any surface, especially fabric. It offered a way of protesting the material dominance of Kodak cameras, papers, and film and of attacking the pretensions of art objects and the look of conventional art photographs. In the 1960s, artists such as Robert Heinecken and Robert Fichter did not so much explore the cyanotype as unleash it. Catherine Jansen photosensitized fabric and objects with cyanoemulsion and turned rooms into blue dens of adolescent iniquity. Politics met process. Yet even for the iconoclastic Fichter, the industrial blue was first and foremost the means to a transformative end, to communicate "our hopes, fears, daydreams, and nightmares."[48]

There is no resolving the contradiction of the cyanotype. It seduces contemporary Henry Bosses such as English chemist Michael Ware, the foremost modern authority on the process. Ware's blues, developed through his own research into the cyanotype process, are so intense they lift his landscapes out of the quotidian and into an archetypal realm.

The work of former architect Robert Schaefer marries the process to a Machine Age aesthetic of urban geometries and industrial technologies. The precision of these images prompts the question of why the Bauhaus photographers and proponents of the "new objectivity" of the 1920s did not use cyanotype. Schaefer also reverses himself with a blue neo-Impressionism, images that might have originated in the Photo-Secession and photography's embrace of painting.

Blue in contemporary work is a herald of vision, the sign of imagination's inward turn. Perception swerves deliberately from codified seeing, whether the artist's purpose is allegorical, political, or abstract. Like black-and-white photographer Hiroshi Sugimoto, Anita Chernewski has photographed extensively in front of the dioramas of the American Museum of Natural History. While Sugimoto's exquisite silver prints play on the almost-aliveness of the tableaux (or on the half-deadness of living reality), Chernewski's cyanotypes of animals frozen in their artificial

business emblematize a primordial wildness. Blue emphasizes not the artificiality but the symbolic power of this natural world framed behind glass. Animals have never been just animals; rather they are avatars of a divine otherness. Maintained in representation but pushed to the margins of the real world, animal presences impose on Chernewski, and neither artistic neutrality nor mere irony is possible in the face of this enduring mystery.

Likewise, the neutrality of silver is impossible for John Dugdale, and the reasons are practical as well as aesthetic. Dugdale was a successful fashion photographer in the early 1990s, who capitalized on a nostalgia for elegance embodied in his large-format camera and the attentive images he made with it. When he began to lose his eyesight as a complication of AIDS, he turned to the cyanotype as the most easily manipulable photographic technique. Constructing each image in his mind's eye through an aesthetic shaped by his immersion in William Henry Fox Talbot's work, Dugdale is able to arrange and shoot each image and print it out in sunlight, using ordinary tap water. He shares with a number of other old-process photographers a willingness to bypass the darkroom. Many of them began working in the minimal technique of cyanotype because, at one time or another, they had no access to a darkroom.

Much of Dugdale's imagery borrows directly from the work of Talbot, and he has documented his own pilgrimage to Lacock Abby, Talbot's home. With his portentous allegorical titles, his work also recalls the symbolist tendencies of the Photo-Secession, and especially of F. Holland Day. Focusing on the nostalgia of such homages perhaps misses the point. Dugdale's continuing preoccupation is with the components of photographic seeing and how these relate to the conditions of his own fragile being and the possibilities of expression. His most celebrated image, *Farmhouse Inverted in Mark Isaacson's Venini Vase,* is the visual equivalent of a John Donne poem, with multiple layers of reference to the idea of reflection. In the photo, the image of the farmhouse mimics the inverted position of images in a view camera and becomes a metaphor for a process that is part natural, part constructed. In other images Dugdale uses his nakedness to portray a spiritual and sensual condition necessary for making art, a stripping away of false appearances. "Eyesight and vision are completely different," he has remarked. "Vision starts inside my head."[49]

For John Metoyer, vision begins with things seen, but these quickly become points of departure into allegorical territory. Even the cyanotype process itself is altered beyond recognition in many of his images. The country around Metoyer's ancestral plantation in the heart of Louisiana is an explicitly allegorical landscape, with traces of a violent and secret past. *Hanging Tree, Daphne Abandoned,* and *Dark Willow* all make visual reference to actual places but are meant to stand for general categories of place and feeling. In this apocalyptic setting, it is always near dark, and the territory is populated with creatures, such as herons and dogs, that glow as if they had been delivered newly minted from the furnace of creation. Metoyer works in the standard blue but also turns images brown by toning his photographs during developing.

Metoyer's brown-toned images recall a closely related non-silver-based photographic process that might be considered the obverse of cyanotype. This is the kallitype, after the Greek word for pencil, and its common variant known as the *Van Dyke brown* print. Like the cyanotype, the Van Dyke is a method for making photographic prints. After the iron-coated paper is exposed to the negative, it is washed in a solution of silver nitrate, producing a brown tone that can be warm or cool, rich or vague, depending

on the particular chemicals and papers used. Herschel discovered the process but, characteristically, didn't bother to patent or even name it. That didn't happen until 1889.

The effect of a kallitype is less strange but more ambiguous than that of a cyanotype. It can look at first like many people's idea of an "old" photograph, the sort of sepia-toned Polaroid faux albumen. It can also mimic the qualities of the more "noble" and expensive platinum-based print, a chameleon property that caused the kallitype to be banned for decades from most juried photographic exhibitions.[50] Its true visual lineage probably lies in drawing and etching. Its tonality suggests the colors produced by ink on paper in the seventeenth century. "Van Dyke" refers to Anthony Van Dyck, the seventeenth-century Belgian painter. Most cyanotypists also print in Van Dyke and often combine the two processes, as a kind of yin and yang of photographic possibility. If the cyanotype is never far from the geometric abstraction and industrial process of the blueprint, the Van Dyke is never far from the handcrafted tradition of the fine arts.

Jan Van Leeuwen's work offers a vivid example. The Dutch photographer alternates between blue and brown methods, as if from mood to mood. But two bodies of work in particular he saves for his precise and elegant kallitypes. In essence, all Van Leeuwen's Van Dyke prints are still lifes, emblems, including his best-known series, in which he uses multiple exposures of his naked, aging body to create tableaus of sacred Christian scenes, including the Last Supper and the Supper at Emmaus. His obvious antecedents in the visual interpretation of scripture are painters—Rembrandt and Caravaggio—but the medium of the photograph adds another dimension to Van Leeuwen's interpretation of Christianity.

He grew up in Holland during the Holocaust, and, while others suffered and disappeared, he watched. In the confrontation with his memories, the Christian message of love and mercy is not merely an ethical option but a human necessity. If all human beings are called by Christ's example to enact the sacred story of charity, mercy, and sacrifice, to "go thou and do likewise," and if each work of art depicting such events also participates in or enacts sacred time, then so, too, does each photograph, each reproduction, each print, however distant from the original. In Christian terms all "original" works of art are no better than copies or repetitions of the sacred model, but by the same token, all copies are authentic reenactments, as invested with the spirit of the events they depict as the original biblical events.

In one sense, Van Leeuwen may be the most radical photographer at work today, for his work shows photography as nothing less than a manifestation of the miracle of transubstantiation, the continuous participation of made things in the profound mystery of spiritual indwelling. It seems only right that he would choose the humblest and most disdained of photographic processes to make his point. As the Bible says, "The Last shall be first."

1

anita CHERNEWSKI

1 **african dogs**. 1985. van dyke print, 3 ½ x 4 ½ inches

2 **chances**. 1990. cyanotype photogram, 3 ½ x 7 ½ inches

2

1

JOHN DUGDALE

1 **farmhouse inverted in mark isaacson's venini vase.** 1994. cyanotype, 10 x 8 inches

2 **restored torso.** 1997. cyanotype, 10 x 8 inches

3 **my spirit tried to leave me.** 1994. cyanotype, 10 x 8 inches

2

3

1

ɢᴀʟɪɴᴀ ᴍᴀɴɪᴋᴏᴠᴀ

1 **papir**. 1990. handmade paper with fragments of photography on porcelain, 24 x 20 inches

114/115    2 **untitled**. 1989. cyanotype on silk, 47 ¼ x 70 ¾ inches

2

mark DUNGAN

1 **sphinx**. 1999. van dyke print, 2 ½ inches in diameter

2 **rocket**. 2000. cyanotype/van dyke print, 4 ¾ x 2 ⅜ inches

LAJOS SIRÓ
**body images V11**. 1998. kallitype, 15 ¾ x 8 ½ inches

1

2

JAN VAN LEEUWEN

1 **barbed wire no. 7.** 1993. cyanotype, 15 ½ x 12 inches

2 **barbed wire no. 9.** 1993. cyanotype, 15 ½ x 12 inches

3 **the meal at emmaus.** 1996. kallitype, 15 ½ x 12 inches

3

ROBERT SCHAEFER, JR.

train station, hannover, germany. 1979. cyanotype, 12 x 18 inches

mike ware

**il salvatore, sicily.** 1989. new cyanotype, 9 ½ x 7 ½ inches

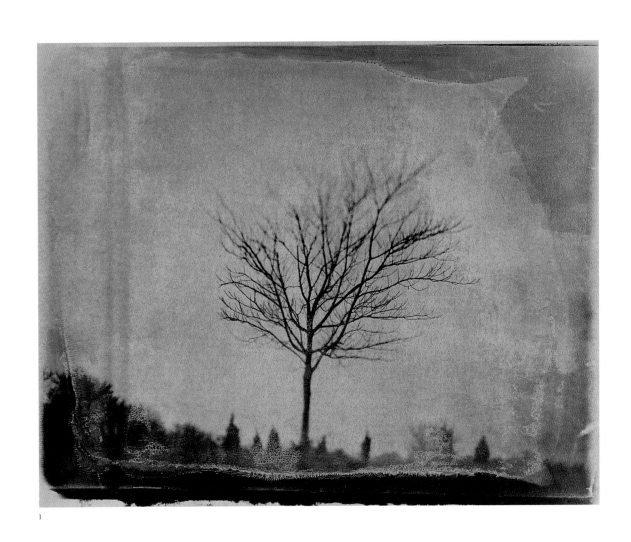

1

JOHN metoyer

1 **november**. 1999. toned cyanotype, 17 x 21 inches

122/123    2 **pice**. 1999. cyanotype, 16 x 20 inches

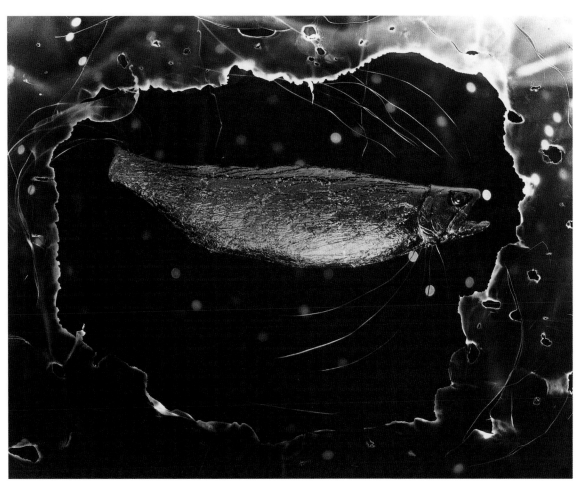

2

LUCAS WERTH

road to shah can carakh. 1999. chrysotype, 8 x 10 inches

CRAIG BARBER

**thompson & bleecker.** 1990. van dyke print, 8 x 20 inches

**BARBARA KASTEN**

**amphora lebanon 3rd century** A.D. 1996. photogram cyanotype, 44 x 30 inches

1

2

ANNA HAMMOND

1 **tulips**. 1997. cyanotype, 36 x 51 inches

2 **untitled**. 1999. cyanotype, 16 x 40 inches

At work in the Polaroid Studio in New York City, Ellen Carey seems as far removed from the origins of photography as one could travel. The 20-by-24-inch camera she uses seems a gigantic parody of William Henry Fox Talbot's early "mousetrap" camera, which he constructed on a rodent scale in order to concentrate the light. Carey's process doesn't seem to be photography at all. Where Talbot would leave his negatives in the sun for hours, until the images emerged into full definition, she takes an eight-foot sheet of positive Polaroid film and literally pulls it through the camera, producing an elongated pattern of colored emulsion—an instant Morris Louis painting on film. Nonetheless, Carey's foremost influence is Talbot, and her work is as much an homage as any salt print of Lacock Abbey, Talbot's ancestral home. Where Carey and Talbot meet is in the territory of first facts, prior to any image, prior even to the camera, a territory of light and dark, of the impersonal registration of photons.

Throughout photography's evolution, there has been a continual need of artists to reenter this territory and return to origins. Carey's "pulls" are an extreme version of the chief method of artistic rebarbarization, the photogram. A photogram is nothing more than an outline, a silhouette, registering where light falls and where it is obscured by some intervening object. According to the Roman historian Pliny, the longing to fix shadows is as old as the mythical desire for a representation so faithful that it might somehow come to life or recall a presence. Who knows how long artists have used the outline of shadows to guide their pencils? The X ray is a photogram. A bathing-suit mark made by a sunburn is a form of photogram. So are the outlines of victims fixed by radiation on the walls of ruined buildings in Hiroshima and Nagasaki. So, too, are the grass pictures made by English artists Heather Ackroyd and Dan Healy. They project photographic images onto growing grass, and the pattern of shadow controls photosynthesis, creating over time an indelible image in shades of green.

Nearly forty years before Talbot made his own photograms, Thomas Wedgwood placed leaves on paper coated with silver salts. Wherever light struck the paper, it darkened. Where the object shielded the surface, the paper remained white. The result was a "negative," or reverse silhouette, image, perfect in outline, no camera necessary. Wedgwood could not prevent the image from developing further once he removed the leaf, however, and so gave up the process. Talbot called his own versions sciagraphs—shadow graphs—and used them as stepping stones to photography, the capturing and fixing not just of shadows but of images themselves.[51]

Why, then, return to shadows, or proceed further toward "photography degree zero," as Carey has called her use of only emulsion, paper, and light? Why pursue the ultimate oxymoron—an abstract photograph? Carey began by making technically complicated color photograms, with multiple exposures, then proceeded to *photogenic drawings*, another inspiration from Talbot, who coined the term. In these abstract works, she drew with a light pen directly on film, leaving a reticulated narrative of the hand. Talbot worked from negative to positive. Carey's light drawings are direct positives, from which she often makes darkbackground negatives, reversing Talbot's movement toward naturalistic representation. But even this has seemed too constraining. In the Polaroid "pulls," Carey has eliminated the mediating hand, and along with it any visual reference to a realm prior to

the photographic process. She is not alone. Ilan Wolff, Susan Rankaitis, and Bruce McKaig all began with photogram shadow images and evolved toward large-scale photographic abstraction, letting the chemistry of the photographic emulsion register chance and time. They turn Talbot's celebrated "pencil of nature" into a paintbrush.

Talbot and his colleagues and friends in photography were privileged early seers, and every image they produced was new. They responded without prejudice to all aspects of the image. First and foremost was not its accuracy but rather its color, clarity, and form. For Anna Atkins, who in the early 1840s began to assemble a book of botanical photograms in blue cyanotype, the shadow images possessed an aesthetic life of their own. Her photograms of plants are like X rays, revealing structure as well as shape. The radical restrictions of the medium clarify vision, reduce the information in the image, and separate it from nature's rich and complicated visual clutter. Anna Atkins, botanist, was amazed not so much by the beauty of nature but by the beauty of the images she produced, with nature's collaboration.

In spite of the photogram's direct and powerful connection to the principle action of photography, it inevitably came to be regarded as nothing more than an infant stage of negative-to-positive photographic representation. The process was not superseded; it simply became unimportant to photography's documentary role. Decades later, in the 1920s, the photogram reappeared. Artists influenced by a transformed vision of the natural order of space and time reinvested the photogram's qualities with a new relevance. In its second incarnation, this precursor of photography became a quintessentially modern art form.

By the 1920s, Einstein had introduced his general theory of relativity. Freud had published most of his works, including *Civilization and Its Discontents,* and philosophers such as Ernst Mach and Ludwig Wittgenstein had begun to reveal the ways in which language structures the apprehension of reality, a reality that is described by probability, not logical necessity. Human beings occupied a relativistic universe in which space and time were elastic, and knowledge was limited by the perspective of the observer. Likewise, human identity was not a stable, self-possessing entity but a gathering of unbidden impulses, linguistic structures, and temporary, contingent events. Cubism created the image of this new universe in its open-ended, multifaceted presentation of visual form. Each thing, human or inanimate, could be rendered from different perspectives and at different instants in a single image. It was impossible to tell where subject left off and viewer began, where object ended and experience began.

Emmanuel Radnitsky, better known as Man Ray, saw profound implications for art and artists in this transformation. For one thing, the artist could no longer maintain an exalted position as a destiny-controlling originator of form. Rather, the artist was the manipulator of chance, the temporary harnesser of forces, "the impassive gambler," as André Breton said of Man Ray.[52] For another, human vision and possibility were open-ended. The structure of society and human identity were based not on inherent principles but on convention; they were arbitrary and could be remade along more authentic or visionary lines. Radnitsky took a new name and invented a "new" method of art—the Rayograph, which was a photogram. In fact, Christian Schad was already making modern photograms, but legend has it that

chance reinvented the form when in 1921 Ray accidentally left some objects lying on unexposed negative film and rediscovered the method. Man Ray's new version was abstract, complicated, technological. It was less a means of expression than a deliberate orchestration of natural forces.

The sharp, impersonal, scientistic edge of the future appealed to many artists discontented with what seemed after World War I an unworkable past. Even though the photogram remained a comparatively minor form, as symbol and provocation it changed everything. Revolutionary Russian Constructivists such as Alexander Rodchenko and El Lissitzky, Bauhaus advocates of a "new objectivity" in art and society, including Laszlo Moholy-Nagy, Dadaists seeking anti-art strategies of the readymade, and Surrealists seeking a port of entry to the dreamscapes of the unconscious all adopted the photogram. It could almost be called a Rorshach test for modern art. As Moholy-Nagy remarked, "Light studios should take the place of the outdated painters' academies."[53]

The contemporary photogram is predominately a field for the exploration of process and metaphor. Among the most suggestive contemporary photograms are those composed by Iranian-born Shirine Sharif Gill. She could be seen as the second coming of Anna Atkins. She has overexposed her delicate botanical photograms, allowing the background to go toward black, leaving images that are gray as shadows. These images exist between positive and negative, between decoration and contemplation. It is possible to feel their perceptual ambiguity as a physical sensation. Sharif Gill resists interpretations of her work as in any way "Persian," yet the work offers itself as a mode of enlightenment, similar in spirit to the parables of classical Islamic sages.

The teaching lesson of Attar of Nishapur, a twelfth-century literary master, suggests a comparison with Sharif Gill's dark light:

> The Moon was asked: "What is your strongest desire?"
> It answered: "That the sun should vanish, and should
> remain veiled for ever in the clouds."[54]

In the investigation of nature, the photogram lends itself to Romanticism, as it has since the beginnings of photography. In the early nineteenth century, Tom Wedgwood spent hours discussing the optics and ontology of the nascent art of photography with the poet Samuel Taylor Coleridge. Photography seemed to Wedgwood to herald a changed relationship between human beings and nature. The photogram offers a means of both direct participation in natural processes and symbolic discourse about nature. Such photo-Romanticism marks the work of Susan Rankaitis. Preoccupied by science, the former abstract painter has created a series of photograms based on images of DNA, nature's recombinatory art, synthesized from chemicals according to chance and the principles of physics. Her more recent abstract overlays of chemical emulsion on large sheets of paper, which undergo subtle transformation upon continued exposure to light, suggest the ultimate identification of the work with its subject, which is the unfolding of the physical universe itself.

Susan Derges's more pastoral Romanticism might be described as an Englishwoman's attempt to go the poet William Wordsworth one better and allow nature to see itself. Her cameraless work stretches the definition of a photogram to such a degree that it is easy to overlook the fact that most of her images are made within narrow and demanding constraints. Within those

constraints, she allows chance and natural process to operate. In the *River Taw* series of 1999–2000, Derges, working at night, placed large sheets of sensitized paper just below the surface of the river, then exposed them with a flashlight. The result is the world as it might look to the river itself, or to a drowned Ophelia, with shadows of trees, branches, and fallen leaves floating on the surface of the water, on the surface of the river's vision.

As philosopher Friedrich Nietzsche understood, any return to first principles, whether in art, morality, or religion, inevitably carries political implications. It involves a turning away from complexity and sophistication in favor of energy and potential disorder, from which new orders can emerge. Of all the artists using variants of the photogram, Argentinian Graciela Sacco has committed herself most rigorously to the disturbing and redistributive power of photography. Technically, Sacco is not a photogram artist. She calls her work "heliography," referring to Nicéphore Niépce's original description of photography. Like a number of U.S. artists in the 1960s, Sacco coats objects with photosensitive emulsion, then projects images onto them, in effect using the physical objects as "prints." In her art, images spring up everywhere—on suitcases, slats of wood, refrigerators, spoons, postage stamps, and even from flashlights. For Sacco, who began making art at the end of the 1970s, just as Argentina was emerging from military rule and the true magnitude of the "disappearances" was coming to light, photography is more than a means of personal expression. By surprising the eye, she fashions a metaphor for moral vision, for the recovery of true sight after a time of darkness.

Since the late nineteenth century, photographs have been enlisted in political service, their truth value marshaled against official pieties, obfuscation, and the status quo in order to show "how things really are." For Jin Lee, early photography resonates with her concern for the propagation of cultural stereotypes. Lee makes photogram silhouettes, a method of tracing with light similar to that employed by artists in the eighteenth century. Her portrait gallery of contemporary profiles contrasts the irreducibly polyglot nature of humanity and its lack of intrinsic significance with reductive attempts to categorize human beings. Her images suggest the camera's use by nineteenth-century anthropologists and later advocates of racial purity to assign a typology to the so-called primitive peoples they encountered and to rank them in an evolutionary pyramid.

To begin from scratch, as photogram artists do, is to break habits, not merely habits of seeing but the more insidious habit of averting one's eyes. In their different ways both Lee and Sacco link the pleasure of photography, a pleasure that could once again rekindle the desire to see, with the responsibility and the shock that come with seeing—the positive with the negative. Their art asks implicitly, "Having seen, what will you do? How will your world be rearranged?" It is an eloquent formulation of photography's enduring moral challenge.

1

SUSAN DERGES

1 **the river taw, 29 july 1997.** 1997. photogram, 66 x 24 inches

2 **waterfall, 13 march 1998.** 1998. photogram, 97 ¼ x 41 ¼ inches

3 **shoreline, 6 october 1998.** 1998. photogram, 95 ½ x 40 ¼ inches

2

3

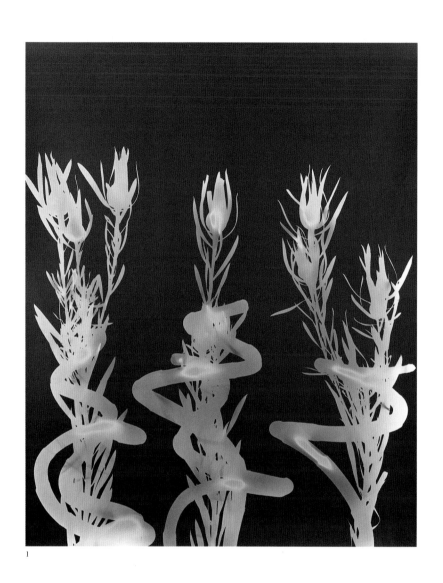

1

SHIRINE SHARIF GILL

1 **untitled.** 2001. photogram, 20 x 16 inches

2 **untitled.** 2001. photogram, 20 x 16 inches

2

1

ILaN woLff

**1 place de la bastille**. 1997. stenogram (photogram with pin-hole camera), 79 x 50 inches

**2 notre-dame**. 1997. stenogram (photogram with pin-hole camera), 12 feet 1 ¼ inches x 50 inches

2

1

2

eLLeN caRey

1 **photogenic drawing.** 1999. paper negative toned, 20 x 16 inches

2 **photogenic drawing.** 1999. photogram toned, 20 x 16 inches

3 **no. 59.** 1996. photogram c-print, 24 x 20 inches

1

amanda means

1 **lightbulb 0010-c**. 2001. color polaroid photogram, 24 x 20 inches

2 **lightbulb**. 2001. photogram, 24 x 20 inches

2

BRUCE McKaig

**untitled**. 1992. color pencil on silver gelatin print (negative printed with photograms), 12 x 16 inches

SUSAN RANKAITIS

**gold science ghost drawing #2.** 1997. photogram and emulsion, 50 x 67 inches

**100 spoons floating (installation detail).** from the **bocanada** series. 1997–2000. heliography on spoon

JIN Lee

**untitled (montage).** from the **untitled heads** series. 1993–95. nine silver gelatin print photograms, 14 x 11 inches each

1

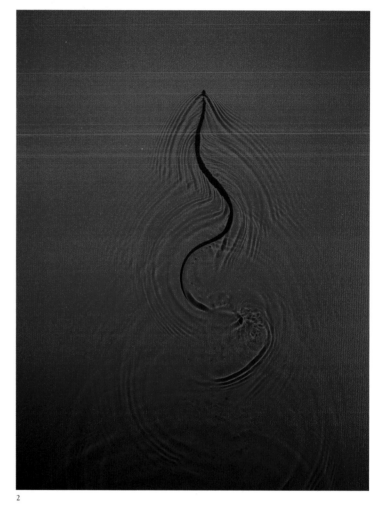

2

aᴅam fᴜss

    1 **untitled**. 1992. cibachrome photogram, 65 ½ x 49 ½ inches

    2 **untitled**. 1997. cibachrome photogram, 40 x 30 inches

    3 **untitled**. 1994. cibachrome photogram, 40 x 30 inches

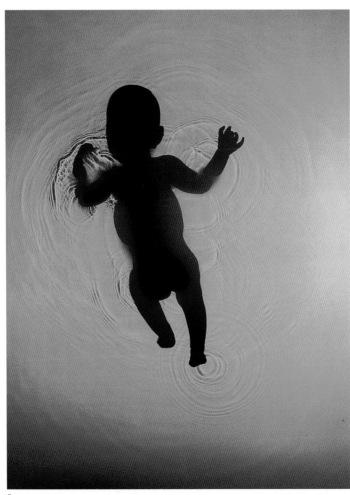

3

The following descriptions of terms and processes are meant to enrich the appreciation of the work contained in this book, and to provide a sense of how photography evolved. Although culled from manuals, the entries are not meant to be used as such (see the bibliography), but rather as a set of footnotes to the text. Glossaries are not usually read from A to Z, but anyone disposed to do so in this case will likely emerge with a good idea of why photographers still enjoy getting their hands dirty with old processes.

### albumen print

Invented in 1850 by Louis-Désiré Blanquart-Evrard, the albumen print was the most popular photographic printing process until the 1890s and the advent of the silver gelatin print. Its major advantage over the salt print was that the image was suspended in a coating on the surface of the paper rather than being absorbed into its fibers, thus resulting in a sharper image. To make an albumen print, a sheet of paper is floated on a solution of egg white and sodium chloride. After the paper dries, it is sensitized by floating on silver nitrate and dried again in the dark. The paper is exposed in contact with a negative and then placed in the sun to print (see *printing-out paper*). The printing process can range from only a few minutes to an hour or more. In the nineteenth century, albumen prints offered photographers the opportunity to produce multiple prints fairly easily from a single negative, tolling the death knell for one-of-a-kind direct-positive processes such as the daguerreotype and ambrotype.

### ambrotype

The ambrotype is a collodion-on-glass image that has been underexposed and then developed in iron sulfate and fixed in cyanide (see *collodion*). When placed against a dark background, the result is a positive image of high definition. Dark-colored "ruby" glass was often used for an especially elegant effect. The process was patented, although not invented, in 1854 by James Ambrose Cutting, who popularized it in the United States. But it was not named after him. Marcus Aurelius Root gave it the name after the Greek word *ambrotos*, meaning imperishable. Apparently, Cutting then changed his middle name from Anson to Ambrose, perhaps to solidify his proprietary interest. Similar to daguerreotypes in size, appearance, and mechanics, ambrotypes were also used primarily for portraits and were presented in hinged cases like those used for daguerreotypes. Since the ambrotype was faster, cheaper, and simpler to produce, and the resultant image was nonreflective and thus easier to view, the new process soon replaced the daguerreotype.

### calotype negative

The word *calotype* derives from the Greek *kalos*, beautiful, and the Latin, *typus*, image. William Henry Fox Talbot coined the word to describe his 1840 discovery of the developed-paper negative, which he used to create a positive print. He had already discovered a way to make printed-out negatives on paper, letting them emerge slowly in sunlight. Unlike the daguerreotype, calotype photography involved a two-step process of negative to positive image-making. With early negatives, which were made with uncoated paper, the image is embedded in the fiber of the paper rather than resting on the surface, as in a glass negative. The resulting images, both negative and positive, can be somewhat diffuse, not always a desirable characteristic. Waxing the paper helped make the image sharper (see *waxed paper negative*). In the 1840s, the negatives themselves were considered photographic objects. By the mid-1850s, calotype negatives were replaced by collodion-on-glass negatives.

### camera obscura

This instrument, whose name is derived from the Latin meaning dark chamber, was used by draftsmen after the seventeenth century to facilitate their task by reproducing a three-dimensional object in two dimensions. It is basically a closed box with a lens at one end. In fact, in its simplest form, it has no lens, only a pinhole-size opening (see *pinhole camera*). Light entering through the lens produces an inverted image of the object on which the lens is focused. A mirror attached to the other end of the box serves to project the image onto a glass screen and to reverse the image. This image can then be traced on to paper.

### chrysotype

The astronomer Sir John Herschel, inventor of the cyanotype, also experimented with the chrysotype, which creates images in colloidal gold. Unlike gold toning, in which gold is added to a silver image, the chrysotype is a printing process based on iron salts similar to platinum or cyanotype. The process never caught on in the nineteenth century due to the inconsistency of color and contrast and to fogging. It has been only recently revived, primarily by English chemist and photographer Michael Ware. This process can be used to produce images in a wide range of colors from pink and purple to blue and green in addition to gold.

### collodion on glass negative

The process of making collodion on glass negatives, also known as wet-plate negatives, was announced by Frederick Scott Archer in 1851. It quickly became the most popular type of negative until the 1880s and the availability of ready-made dry-plate gelatin on glass negatives. Collodion on glass negatives were generally used to produce salt and albumen prints, and together these

**the obscura object of desire** depicted in a rare clough engraving (from stephen berkman's obscura installation). copper engraving, 5 x 10 inches

two new processes effectively eclipsed all others. The advantages of collodion were twofold: enhanced resolution and shorter exposure time. Collodion is made from cellulose nitrate dissolved in ether and alcohol. The resulting clear, syrupy substance is "salted" with iodides and bromides and poured onto a glass plate in an even coating. Before the solvent evaporates, the plate is bathed in a solution of silver nitrate, which creates a light-sensitive plate. The plate is placed, still wet, in the camera, exposed to light, and immediately developed, before the collodion dries. Any photographer venturing outside the studio, whether to a nearby garden or halfway around the world, had to take all the requisite chemicals and glass plates, as well as a dark tent or wagon to serve as a darkroom. A slow and inconsistent alternative to this process was the dry or preserved collodion negative, in which an additional coating is added to the sensitized plate to keep it moist, thus allowing the photographer to prepare the glass plate in advance.

### contact print

A contact print is made by putting light-sensitized paper in direct contact with a negative and exposing it to light. Whether the final print is then developed in chemicals or printed out in the light, it is the same size as the negative. Since the practice of enlarging a negative was not mastered until the 1880s, most nineteenth-century photographs were produced through contact printing.

### cyanotype

In 1842 the astronomer Sir John Herschel, who had discovered the light sensitivity of iron salts in his scientific research, invented the cyanotype. In this photosensitive process, paper, coated with a solution of iron salts and dried in the dark, becomes light sensitive. An object, a drawing, or a negative is placed in contact with the paper and then printed out in direct sunlight. After exposure, an image appears as mauve against a yellowish background. Washing the exposed paper in water fixes the image and brings out a brilliant blue color (cyan), called *Prussian blue,* through the process of oxidation. The cyanotype is comparatively simple to make. It is always printed out through exposure to light, not developed with chemicals.

### daguerreotype

The daguerreotype, introduced in 1839 by Louis Jacques Mandé Daguerre, was the first photographic process to enjoy widespread commercial success, only to be superseded two decades later by ambrotypes, tintypes, collodion on glass negatives, and albumen prints. The advantage of the daguerreotype over other processes was its stunning clarity. A daguerreotype is a unique photographic image on a sheet of copper coated with silver. Because of its delicate nature, in the nineteenth century it was usually preserved in a sealed leather case under a sheet of protective glass. The image sits on the surface of a polished silver-clad plate, so it is highly reflective and must be viewed from an angle. The process of producing a daguerreotype involves a series of complicated steps. The silver-coated plate is carefully cleaned and polished by buffing then fumed with iodine and bromine in a closed container to produce a light-sensitive surface. The sensitized plate is exposed in a camera and then developed by the chemical action of mercury vapors on the exposed silver iodide surface to produce an image. The plate is fixed and can be toned with gold chloride to enhance its color and reinforce the image.

### developing-out paper

From the 1870s on, photographers had access to paper coated with a silver-based emulsion for the production of photographic images from negatives through the process of chemical development. Developing-out paper is exposed under a negative to artificial light, in an enlarger or in direct contact with the negative. This results in a so-called latent image, which is then brought out by chemical development. Prior to this, prints from a negative were produced by the process of printing out, in which sensitized paper in contact with a negative is placed under a light source, whether artificial or natural, until an image appears without chemical treatment. The early developing-out papers were so improved during the last decades of the nineteenth century that by 1900, albumen prints were considered an outdated and inadequate process.

### emulsion

An emulsion is a viscous medium in which silver halides (silver bromide, silver chloride, silver iodide) are suspended. It is applied to film, plates, and paper to create a light-sensitive coating. In the early days of photography, gelatin, albumen, or collodion were used as the binder to suspend the chlorides, bromides, and iodides only. A second application of silver was needed to produce the light-sensitive silver halides.

### ferrotype (see *tintype*)

### gum bichromate print

Gum bichromate printing was invented in the 1850s but did not become popular until the end of the nineteenth century with Robert Demachy and the Photo-Secessionists, especially Edward Steichen. This process enabled photographers to create an image with a broad range of tones and diffuse details, resembling a charcoal drawing or a watercolor. A solution of gum arabic, pigment, and potassium bichromate is brushed onto paper.

After drying, the paper is exposed to light in contact with a negative. The gum bichromate hardens in direct proportion to the amount of light exposure. Where the negative is dark, less light reaches the paper, and the gum does not harden. The soluble gum bichromate is washed away with water. The photographer can further manipulate the print by brushing the surface or directing a stream of water onto the gum bichromate, or exposing the print a second and even a third time after coating it with another layer of gum bichromate.

## kaLLItype

Patented in 1889 by the chemist W. J. Nicol, the kallitype is essentially an extension of Herschel's invention of the cyanotype. Unlike the cyanotype, which relies entirely on iron salts, the kallitype is based on a mixture of iron salt, oxalic acid, and silver nitrate to create a light-sensitive paper. This paper is exposed to light (usually sunlight), in contact with a negative, and then developed in a variable chemical solution, which determines the final color, ranging from black to brown and sepia to purple. The Van Dyke print, one of the variants on the kallitype also patented by Nicols, requires shorter processing steps and fewer chemicals. It can be applied to almost any fabric, including T-shirts. As a result, it is now one of the most popular of the historical processes.

## kwik print

One of a number of modern silver emulsions used to render surfaces photosensitive. Such emulsions have been used to "print" images on everything from suitcases to bedsheets.

## Latent image

A latent image is the invisible image that is imprinted on film, silver, iron or glass plates, or developing-out paper coated with a silver halide emulsion when exposed to light. This image later becomes visible when the film or paper is placed in a chemical solution.

## photogenic drawing

When William Henry Fox Talbot began his first experiments with photography in the 1830s, he was able to reproduce an image in negative, which he called a photogenic drawing. Initially, this process did not even require a camera (see *photogram*). To produce a photogenic drawing, a smooth piece of paper is coated with a solution of sodium chloride, dried, and then brushed with silver nitrate. Objects are placed directly on the paper, which is then printed out in the sunlight. The result is a visible image, in negative, which was stabilized with a solution of salt to prevent unexposed areas from further darkening in the light. Having produced a negative image, Talbot continued his experimentation with a primitive wooden box and lens that served as a camera. He produced a paper negative that was printed out and then placed this in contact with a second piece of photogenic paper to create a positive print.

## photogram

William Henry Fox Talbot's first experiments with photography resulted in his photogenic drawings, which were among the earliest of what, much later, became known as photograms. A photogram is a photographic image that is created without a camera and relies entirely on the action of light on light-sensitive film or paper. An object is placed directly on the film or paper. Where the object blocks the light, the paper is not exposed and remains white. The range of tones created in the final image depends on the density of the object. If the object is translucent, a whole range of intermediate tones can be created, not merely a simple silhouette.

## pinhole camera

A pinhole camera works on the same premise as the camera obscura but does not employ a lens. It is a closed box with a pinhole on one side. Light passing through the narrow opening is diffracted and projects an inverted image back onto a surface of the box. Film can be positioned in front of that surface to capture the image. Because the pinhole has no lens, the image has no depth of field. And because the opening in a pinhole camera is so small, the film or paper requires a long exposure. The simplicity of this technology lends itself to imaginative uses. Any closed space, of any size, from the back of a truck to a washing machine to an entire warehouse, can be transformed into a camera.

## platinum print/palladium print

In 1873 William Willis was able to produce a viable platinum paper. This paper was available commercially by 1879. In platinum printing, a piece of paper sensitized with iron salts is exposed to light in contact with a negative until a faint image appears. This paper is developed with chemicals in a process that dissolves the iron salts and replaces them with platinum, thus further bringing out the image. The final print has a range of tones from brown to silver to gray and a surface texture not obtainable with gelatin silver prints, and the process produces the most stable metal-based print available. For these reasons, many fine-arts photographers used platinum printing in the late nineteenth century, and many use it today. During World War I, as the cost of platinum rose, palladium, which was somewhat cheaper than platinum but depended on the same process, was introduced as a substitute.

## printing-out paper

Printing-out paper refers to silver-chloride paper that is

used to produce a photographic print from the action of light energy on the paper in contact with a negative. The image appears during the process of exposure to light, not in a developing tray with a chemical bath. The exposure process can be halted at any time, at which point, the excess silver is removed in a water bath, and the print is toned (optional), fixed, and washed again.

### salt print

This process for creating the first positive prints on paper was developed by William Henry Fox Talbot in the 1830s and built upon his discovery of photogenic drawing (see *photogenic drawing*). The surface of a salt print is matte, and the first paper used was ordinary writing paper. The photographic image is embedded in the fibers of the paper, rather than suspended above on the surface as with albumen and silver gelatin prints. For this reason, the details lack definition. A salt print is typically printed out without chemical developers in contact with a paper negative (see *calotype*) or collodion on glass negative. To produce a positive print requires a long exposure time—up to fifteen minutes in sunlight. In the nineteenth century, the final result was often toned with gold chloride to increase stability and contrast. The salt print was largely superseded by the albumen print, introduced in 1850.

### silver gelatin print

When most people think of black-and-white photography, they have in mind silver gelatin prints. These are positive prints that are developed out with chemicals on photographic paper coated with an emulsion in which silver halides are suspended. The first papers coated with an emulsion of gelatin silver halides were introduced in the 1870s, following the introduction of gelatin on glass negatives. This innovation came into

general use in the following decade and has remained the standard form of black-and-white photography ever since. The primary advantages of the silver gelatin print over the albumen print were efficient production with consistent results and greater stability. With that consistency, however, has come a visual homogeneity.

### silver halides

Silver halides are the basic building blocks of silver-based photographic processes. They are the chemical compounds formed when silver is combined with chlorine, bromine, or iodine to make silver chloride, silver bromide, and silver iodide. The resulting silver halides are sensitive to light and are transformed back into metallic silver when exposed to strong light (as in the case of silver chloride) or feeble light with a reducing agent otherwise known as developer. Because the chemicals react at different speeds, they are used both separately and in combination to produce varied results in negative and positive images on film, paper, and glass.

### tintype

The tintype, invented by Hamilton Smith in 1856, is a misleading name, as the process depends on a thin sheet of black japanned iron, not tin, as the support for the image. For this reason, tintypes are also referred to as ferrotypes. Like the ambrotype, the tintype is a collodion image that appears to be a positive against the dark support. It is underexposed and then developed in iron sulfate and fixed in cyanide (see *collodion on glass negative*). With later commercial tintypes, a dry emulsion of silver gelatin replaced the collodion, making the plates more transportable and convenient to use. Tintypes were inexpensive to produce and were a very popular method of portraiture in the second half of the nineteenth century. In some countries, their use by

itinerant photographers persisted well into the twentieth century. Tintypes were sometimes presented in folding cases, but since they were not as delicate as daguerreotypes and ambrotypes, they were often placed in paper folders.

### toning

Toning is a process that changes the imaging substance of a photographic print. In the nineteenth century, toning with gold chloride was a standard practice for salted-paper printers and daguerreotypists. In addition to altering the color, gold toning enhances contrast and improves the stability of the silver emulsion, making the print more resistant to fading and discoloring. Many other metals were used in toning to produce a wide range of colors.

### van dyke print

A Van Dyke print is a kallitype with a deep brown tone, recalling the drawings produced by the seventeenth-century Flemish painter Anthony Van Dyck (see *kallitype*).

### waxed paper negative

This innovation, invented in 1851 by Gustave Le Gray, was a further development of Talbot's calotype paper negative. Le Gray applied wax to paper before sensitizing it in a solution of silver nitrate and potassium iodide. The result was a silver deposit throughout the paper fibers and greater detail in the negative. Another advantage to this method over the collodion on glass negative was that the negative could be prepared in advance and not exposed immediately, although the paper was best used fresh.

### wet-plate photography (see *collodion on glass negative*)

ENDNOTES

1 Peter Schjeldahl, "The Instant Age," *Legacy of Light*, edited by Constance Sullivan (New York: Knopf, 1987) 8.

2 Geoffrey Batchen, "Phantasm: Digital Imaging and the Death of Photography," *Aperture* 136 (Summer 1994), 136.

3 John Wood, *The Photographic Arts* (Iowa City: University of Iowa, 1997) 1.

4 Robert Harbison, "Decoding the Cipher of Reality: Fox Talbot in His Time," *Aperture* 125 (Fall 1991) 4.

5 Victor Stoichita, *A Short History of the Shadow* (London: Reaktion Books, 1997) 11–12.

6 Geoffrey Batchen, *Burning with Desire* (Cambridge: MIT Press, 1997) 35.

7 Gail Buckland, *Fox Talbot and the Invention of Photography* (Boston: Godine, 1980) 32.

8 Peter Galassi, *Before Photography* (New York: Museum of Modern Art, 1979) 11.

9 Quoted in Grant Romer, "The Daguerreotype in America and England after 1860," *History of Photography*, vol. 1, no. 3 (July 1977) 202.

10 The 1998 exhibition "Beyond the Edges: An Insider's Look at Early Photographs," curated by photographer Vik Muniz for the Metropolitan Museum of Art made this point spectacularly.

11 Charles Baudelaire, *The Mirror of Art*, translated by Jonathan Mayne (New York: Doubleday Anchor Books, 1956) 232–33.

12 Walter Benjamin, "Little History of Photography," *Walter Benjamin: Selected Writings,* vol. 2, (Cambridge: Harvard University Press, 1999) 507–30.

13 Paul Strand, in *Camera Work: The Complete Illustrations 1903–1917* (Cologne: Taschen, 1997) 780–81.

14 Weston Naef, telephone interview by author, August 1998.

15 Robert Shlaer, *Sights Once Seen* (Santa Fe: Museum of New Mexico Press, 2000) 52.

16 John Szarkowski, *William Eggleston's Guide* (New York: Museum of Modern Art, 1976) 7.

17 "A Case of Poisoning," *Collodion Journal*, no. 13 (January 1998) 11.

18 Quoted in Judy Seigel, "Violating the Medium," *World Journal of Post-Factory Photography*, no. 3 (May 1999) 16.

19 Claus Honef, *Art of the Twentieth Century* (Cologne: Taschen, 1998) 675.

20 Jeff Wall, "Marks of Indifference: Aspects of Photography in, or as, Conceptual Art," in *Reconsidering the Object of Art 1965–75,* edited by Ann Goldstein and Anne Rorimer (Cambridge: MIT Press and Los Angeles Museum of Contemporary Art, 1995) 252.

21 Art Sinsabaugh, *Six Photographers*, exhibition catalogue (Urbana: University of Illinois, 1963).

22 Christopher James, e-mail correspondence with author, September 2000.

23 Irving Pobboravsky, interview by author, Rochester, New York, July, 2000.

24 *See* Robert Sobieszek, *Ghost in the Shell* (Cambridge: MIT Press and Los Angeles County Museum of Art, 2000).

25 *See* Warren Neidich, *American History Reinvented* (New York: Aperture, 1989).

26 Alfred Stieglitz, *Camera Work: the Complete Illustrations 1903–1917* (Cologne: Taschen, 1997) 107.

27 Ihab Hassan, *Paracriticisms* (Urbana: University of Illinois, 1975) 175.

28 Mark Osterman, interview by author, Rochester, New York, July 2000. Mark Osterman and his wife, France Scully Osterman, have chronicled aspects of early photography in the journal the two founded and edit, *The Collodion Journal*.

29 Roland Barthes, *Writing Degree Zero* (New York: Hill and Wang, 1968).

30 Quoted in Jerrold Seigel, *The Private Worlds of Marcel Duchamp* (Berkeley: University of California Press, 1995) 221–22.

31 Quoted in *Secrets of the Dark Chamber: the Art of the American Daguerreotype*, (Washington, DC: Smithsonian Institution Press, 1995) 15.

32 Quoted in John Wood, *The Scenic Daguerreotype* (Iowa City: University of Iowa Press, 1995) 6.

33 Quoted in Mary Panzer, *Mathew Brady and the Image of History* (Washington, DC: Smithsonian Institution Press, 1997) vii.

34 Sadakichi Hartman, *The Valiant Knights of Daguerre* (Berkeley: University of California Press, 1978) 47.

35 Grant Romer, "The Daguerreotype in America and England after 1860," *History of Photography*, v.1, no. 3, July 1977, 201–12.

36 Quoted in Bates Lowry and Isabel Barrett Lowry, *The Silver Canvas* (Los Angeles: J. Paul Getty Museum, 1998) 48.

37 Roger Taylor, introduction to *Sun Pictures, Catalogue Ten: British Paper Negatives 1839–1864*, (New York: Hans P. Kraus, Jr. Fine Photographs, 2001) 7.

38 Larry Schaaf, in ibid., 10.

39 Quoted in William Eamon, *Science and the Secrets of Nature* (Princeton: Princeton University Press, 1994) 197.

40 Quoted in Susan Sontag, *On Photography* (New York: Farrar, Straus & Giroux, 1977) 183.

41 Jody Ake, interview by author, Brooklyn, New York, May 2000.

42 Sándor Szilágyi, e-mail correspondence with author, January 2000.

43 R.W. Hubbell, "Shall We Take Tintypes?"

*The Collodion Journal*, no. 16, October 1998, 5.
44 John Coffer, interview by author, Dundee, New York, July 2000.
45 From *The Collected Poems of Wallace Stevens* (New York: Alfred A. Knopf, 1954) 165.
46 P. H. Emerson, *Naturalistic Photography for Students of the Art* (New York: E&F Spon, 1890) 196.
47 Charles Wehrenberg, *Mississippi Blue: Henry P. Bosse and his Views on the Mississippi River* (San Francisco: Solo Zone, 2000) 18.
48 Quoted in Robert Sobieszek, "Engaging Fichter," *Photography and Other Questions* (Albuquerque: University of New Mexico Press, 1983) 5.
49 Quoted in Judy Seigel, "John Dugdale," *World Journal of Post-Factory Photography,* no. 5, August 2000, 6.
50 W. Russell Young III, "Kallitype," *Coming Into Focus*, edited by John Barnier (San Francisco: Chronicle Books, 2000) 132.
51 Larry Schaaf, *The Photographic Art of William Henry Fox Talbot* (Princeton: Princeton University Press, 2000) 14.
52 Quoted in *Man Ray* (Los Angeles: Los Angeles County Museum of Art, 1966) 33.
53 Quoted in Floris M. Neusüss, "From beyond Vision," *Experimental Vision: the Evolution of the Photogram since 1919* (Denver: Denver Art Museum, 1994) 12.
54 Quoted in Idries Shah, *The Way of the Sufi* (London: Jonathan Cape, 1968) 65.

## BIBLIOGRAPHY

### MANUALS

There are many manuals for individual processes, including those by Luis Nadeau, Sarah van Keuren, Michael Ware, and John Coffer, to name just a few experts. Among the more comprehensive and accessible are the following:
John Barnier, ed., *Coming into Focus*, San Francisco, Chronicle Books, 2000
William Crawford, *The Keepers of Light*, Dobbs Ferry, NY, Morgan and Morgan, 1979
Christopher James, *The Book of Alternative Photographic Processes*, Albany, NY, Delmar, 2001
Randall Webb and Martin Reed, *Spirits of Salts*, London, Argentum, 1999

### GENERAL

Geoffrey Batchen, *Burning with Desire*, Cambridge, MIT Press, 1997
Jayne Hinds Bidaut, *Tintypes*, New York, Graphis, 2000
Richard P. Brettell, et al., *Paper and Light: The Calotype in France and Great Britain, 1839–1870*, Boston, Godine, 1984
Susan Derges, *Woman Thinking River*, New York and San Francisco, Danziger Gallery and Fraenkel Gallery, 1999
John Dugdale, *Lengthening Shadows before Nightfall*, Santa Fe, Twin Palms, 1995
Lásló Fábiá, et al., *Manu Propria*, Budapest, Esztergom Biannual Exhibition, 1998
Merry A. Foresta and John Wood, *Secrets of the Dark Chamber*, Washington, DC, Smithsonian Institution Press, 1995
Jeffrey Fraenkel, ed., *Under the Sun*, San Francisco, Fraenkel Gallery, 1996

Adam Fuss, *My Ghost*, Calcutta, Laurens Press, 1999
Peter Galassi, *Before Photography*, New York, Museum of Modern Art, 1981
Maria Morris Hambourg et al., *The Waking Dream, Photography's First Century*, New York, Metropolitan Museum of Art, 1993
Elizabeth Janus, ed., *Veronica's Revenge, Contemporary Perspectives on Photography*, New York, Scalo, 1998
Bates Lowry and Isabel Barrett Lowry, *The Silver Canvas: Daguerreotype Masterpieces from the J. Paul Getty Museum,* Los Angeles, J. Paul Getty Musuem, 1998
James Luciana and Judith Watts, *The Art of Enhanced Photography*, Gloucester, Massachusetts, Rockport Publishers, 1999
Floris M. Neusüss, et al., *Experimental Vision: the Evolution of the Photogram since 1919*, Denver, Roberts Rinehart/ Denver Art Museum, 1994
Beaumont Newhall, ed. *Photography: Essays and Images*, New York, Museum of Modern Art, 1980
Larry Schaaf, *The Photographic Art of William Henry Fox Talbot*, Princeton, Princeton University Press, 2000
Larry Schaaf and Hans Kraus, *Sun Gardens: Victorian Photograms by Anna Atkins*, New York, Aperture, 1985
Robert Shlaer, *Sights Once Seen*, Santa Fe, Museum of New Mexico Press, 2000
Robert J. Sobieszek, *Robert Fichter, Photography and Other Questions*, Albuquerque, University of New Mexico Press, 1983
Abigail Solomon-Godeau, *Photography at the Dock*, Minneapolis, University of Minnesota Press, 1991
John Wood, *The Photographic Arts*, Iowa City, Iowa, University of Iowa Press, 1997
Steve Yates, *Betty Hahn, Photography Or Maybe Not*, Albuquerque, University of New Mexico Press, 1995

**PHOTOGRAPH CREDITS**

The author and publisher wish to thank the artists for supplying the necessary photographs. Other photograph credits are listed below.

Dan Estabrook: Courtesy Sarah Morthland Gallery

Gábor Kerekes: Courtesy Sarah Morthland Gallery

Mark Kessell: Courtesy Ricco/Maresca Gallery

Jayne Hinds Bidaut: Courtesy Ricco/Maresca Gallery

Amanda Means: Courtesy Ricco/Maresca Gallery

Sally Mann (landscape image only): Courtesy Edwynn Houk Gallery

Susan Derges: Courtesy Fraenkel Gallery

Deborah Luster: Courtesy Catherine Edelman Gallery

Laurent Millet: Copyright ©Laurent Millet Courtesy Robert Mann Gallery

Luis Gonzalez Palma: Copyright © Luis Gonzalez Palma. Courtesy Robert Mann Gallery

Susan Rankaitis: Copyright © Susan Rankaitis. Courtesy Robert Mann Gallery

Adam Fuss: Courtesy Cheim & Read Gallery

Graciela Sacco: Courtesy World House Gallery

Ernestine Ruben: Courtesy John Stevenson Gallery

Jan Van Leeuwen: Courtesy Jossi Milo Gallery

John Dugdale: Courtesy Jossi Milo Gallery

Chuck Close: Courtesy Pace/MacGill Gallery

**HISTORICAL IMAGES**

Tintype, daguerreotype: Courtesy William Schaeffer, reproduction by Jerry Spagnoli

Anna Atkins, Fox Talbot, Gustave LeGray: Courtesy Hans P. Kraus

PROJECT MANAGER: Harriet Whelchel
EDITOR: Deborah Aaronson
DESIGNER: Brankica Kovrlija

LIBRARY OF CONGRESS CATALOGING-IN-PUBLICATION DATA
Rexer, Lyle.
  Photography's antiquarian avant-garde : the new wave in old processes
/ by Lyle Rexer.
        p. cm.
Includes bibliographical references and index.
  ISBN 0-8109-0402-0
1.  Photography, Artistic. 2.  Photography—Processing—History—19th
century. 3.  Photography—Printing processes—History—19th century.  I. Title.
  TR642 .R493 2002
  770—dc21

                            2001005354

Published in 2002 by Harry N. Abrams, Incorporated, New York

Printed and bound in Hong Kong
10 9 8 7 6 5 4 3 2 1

PAGE 1: Shirine Sharif Gill. *Untitled.* 2001. Photogram, 20 x 16 inches
PAGE 2: Mark Kessell. *Grid I* (detail). 2001. Nine daguerreotypes, 5 x 4 inches each
PAGE 3: Mark Kessell. *Unauthorized Presence II* (detail). 2000. Two daguerreotypes, 5 x 4 inches each

Harry N. Abrams, Inc.
100 Fifth Avenue
New York, N.Y. 10011
www.abramsbooks.com

Abrams is a subsidiary of